BORIS VALLEJO
FANTASY ART
TECHNIQUES

BORIS VALLEJO

FANTASY ART TECHNIQUES

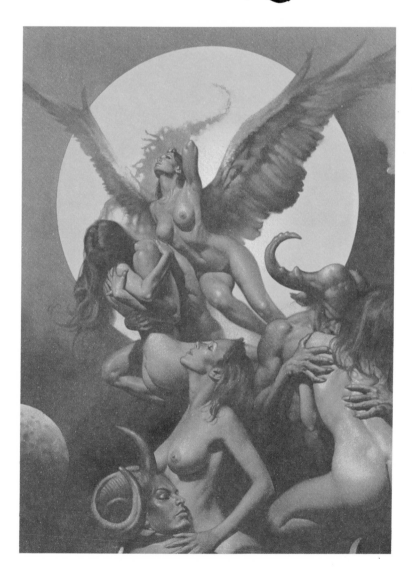

Arco Publishing Inc.
New York

Published by Arco Publishing, Inc.
215 Park Avenue South, New York, NY 10003

Copyright © 1985 by Boris Vallejo

Produced, Edited & Designed by Martyn Dean

Library of Congress Cataloging-in-Publication Data

Vallejo, Boris.
 Boris Vallejo fantasy art techniques

1. Vallejo, Boris. 2. Fantasy in art. 3. Painting—
Technique. I. Title. II. Title: Fantasy art
technique.
ND237.V14A4 1985 759.13 85–11106
ISBN 0–668–06234–7

10 9 8 7 6 5 4 3 2 1

Printed in Portugal by Printer Portuguesa

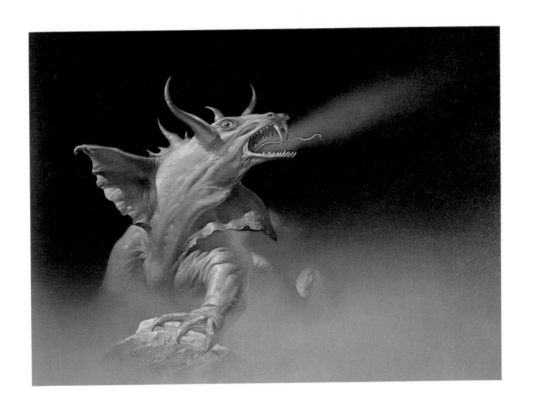

CONTENTS

Foreword by Isaac Asimov 8

Introduction 11

The Concept 14

Seeing 27

Skin Tones 41

The Models & Photographs 49

The Rough Sketch 63

Painting & Underpainting 79

Painting for Heavy Metal 105

Female Wrestlers 112

Chrome Robot 117

Preparing a Portfolio 123

Afterword 127

Foreword by
ISAAC ASIMOV

THE EDUCATED EYE

I suppose that the reason I was asked to do a foreword for this book is that I had something (very indirectly) to do with it. It was for a recent collection of my stories and essays that Boris Vallejo did his "Chrome Robot," which he describes in detail in this book and which you will surely admire as much as I did.

So effective was "Chrome Robot" that the publisher for whom he created it used it as representative of his entire line of books that season, so that "Chrome Robot" appeared on the cover of *Publishers Weekly*. Naturally, then, my name came to mind as a prospective contributor to a book dealing with Boris's art.

An artist who can be as effective as Boris, and who can present the human body (both male and female) in such an extraordinary variety of fantastic forms and poses, has something to teach the young art student, and it is well that Boris has taken on the task. Between the text and the illustrations such a student will find in this book an invaluable compendium of a master's thoughts, devices, and experience.

Having said that, however, I must stop and think. Is this a book only for art students, for those youngsters who dream of a career like Boris's? Undoubtedly, it is *chiefly* for them, but let us be honest. There are not enough of them, perhaps, to make this book realistically profitable if they were all who might be looked on as prospective purchasers. (I know it is disgusting to mention money in the same breath as art, but artists can starve to death as easily as truck drivers can—more easily, if we consider the usual compensations of both—and so can publishers.)

This book is not text alone. It is also a collection of Boris's artistic creations, and this represents a feast for the eye. For every person who has the urge to immerse himself in paints, brushes, and palettes, there must surely be many thousands who, without any ability of their own to produce art, can yet enjoy the artistic products that others have created.

I myself am representative of all the poor souls who lack as much as a chemical trace of ability to produce a shape or form that anyone can look at without wincing. It is all I can do to draw a straight line with the help

of a ruler. If I place onion skin on a line drawing I can trace it in a shaky manner and, as far as colour is concerned, I can tell (with some difficulty) sky blue from apple green. There it ends.

And yet, cursed though I am with a zero-talent pictorial ability, I find myself delighted by Boris's productions and, as I wander from one to another, I almost forget to breathe.

Well, then, is it enough that the book contains a generous display of his work, and shall I urge all those who are only somewhat more talented than I am (no one can fail to be *somewhat* more talented than I am) to buy the book and just look at the art, ignoring the text?

No, never!

The text is easy and interesting reading and it is as important for the art viewer to know these things as for an aspiring artist to know them.

If you are not an artist, you are at least part of the audience and every member of the audience benefits by understanding what it is he admires. It is not only the artist who needs the educated eye, it is you as well. To say "I don't know about art, but I know what I like" is a contradiction in terms. If you don't know about art, you *can't* know what you like because you don't understand what it is you're looking at.

Can you enjoy watching a baseball game, if you know nothing about baseball? Can you enjoy watching a play, if you don't know the language the actors are speaking? You might get some pleasure out of the movements of the players on the field or the actors on the stage, but it would be a weak shadow of the pleasure you would get if you watched with understanding.

Even if the book won't help you be an artist (for an artist must know infinitely more than an onlooker) it will help you be a more knowledge-able onlooker and therefore give you more pleasure. Read—and you will enjoy Boris's paintings more and, in the end, *all* paintings more.

Isaac Asimov © 1985

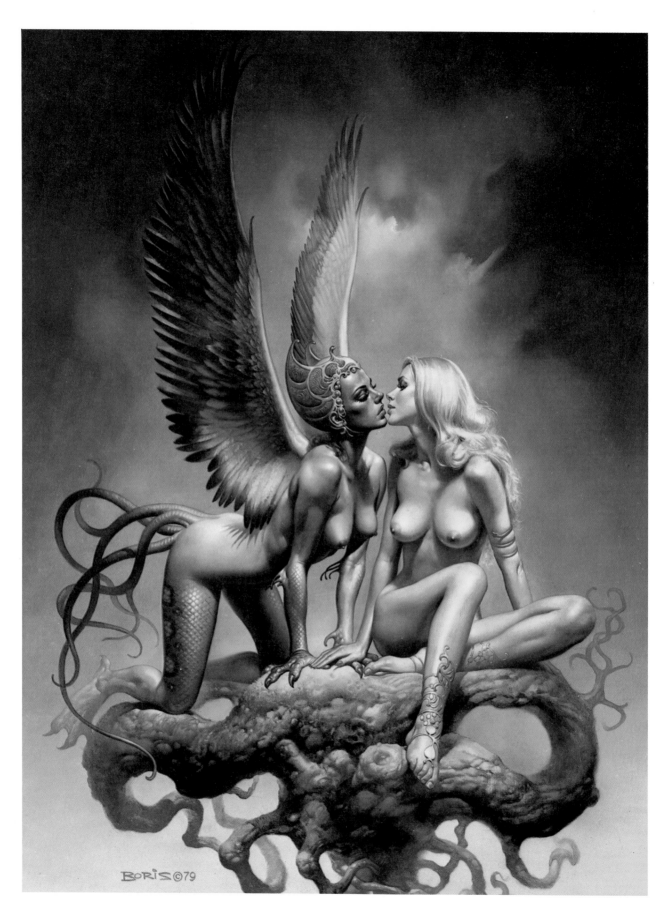

Siren Song, Ballantine.

BORIS VALLEJO
FANTASY ART
TECHNIQUES

Introduction

I have always had the facility to draw. I can't remember a time in my life when I wasn't drawing or painting. In this sense, art has always been a natural part of my existence. When I decided to leave medical school and had to choose a career, there it was. Someone offered me a job doing artwork and I took it.

I had already been working professionally for several years when I began to direct my efforts toward fantasy art. I had tried children's book illustration, mystery, men's magazines, and so on. But something jelled when I became aware of fantasy illustration. I had been involved with bodybuilding for some years and fantasy art afforded me the chance to paint muscular men and voluptuous women as unclad as possible. It was the perfect vehicle for me: I had always loved working with human and animal figures. It gave me an opportunity to do something I enjoyed.

To the question of how my work relates to or reflects my life, I answer that it carries no deeper significance than this: I love bodies; I want to paint them as beautifully as I can. I am interested in what I can do with a figure, and how well I can do it, how close to perfection I can come. And, by "perfection" I don't mean how true to life but, rather, how true to a personal mental image or vision. I strive not only to copy life but also in a sense, to enhance it. One can improve on the shape or proportions of a figure and on the fluidity of its movement in a painting. But one can also, as an artist, utterly enjoy a figure on its own terms, even if it is *imperfect* by contemporary standards.

More or less "self-taught" artists will often discount the value of formal study. On the one hand I agree that the experience of painting itself is the most effective teacher. It is possible to learn by struggling along on your own, making your own mistakes, and doing your paintings away in the wilderness, like a hermit. On the other hand, nothing can take the place of being part of a learning community of your peers. Nothing can replace the constant exposure to the work of others — both those who are better (giving you a goal upon which to set your sights) and those who are not as good (giving you a sense of where you are in the hierarchy, how far along you are, and how much further you can still go).

Good teachers can point the way a bit more directly and they can share their experience with you. What works for some people, however, does not necessarily work for others. By this I mean to emphasize that whatever I say in this book is based on *my* experience. I feel very strongly that there really are no inviolable rules. Existing rules are no more than aids to achieve particular ends. With experience comes the insight to see new ways, the ability to hew new paths, implement new means, and discover what works best for you.

I did go to art school. I did become well acquainted with established methods and rules. I did study and copy the paintings of the Old Masters. Based on this initial groundwork, what proved enormously instructive to me was seeing the original paintings of other illustrators. It is tremendously helpful to see the brushstrokes, the way colour is applied — something that no print of the same piece will show.

From time to time people have commented about my original work: "Oh, that looks so good; it looks just like a print." This has always amused me because I feel that, with rare exceptions, original work contains much more than any print. The subtlety of colour is often lost in printing. Nuances of contrast are lost.

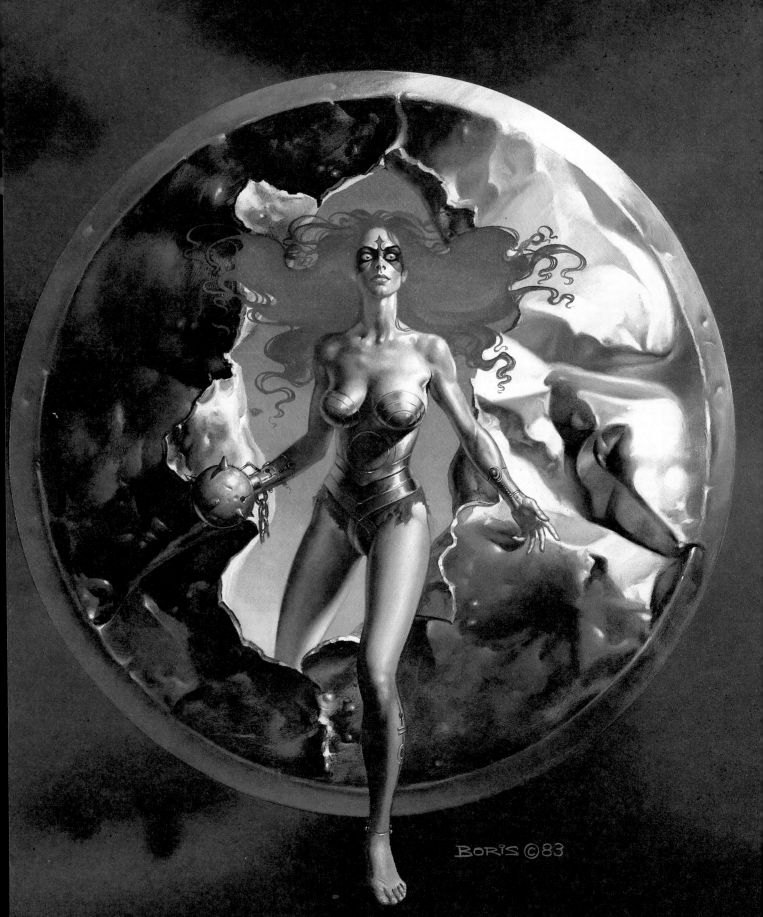

BORIS ©83

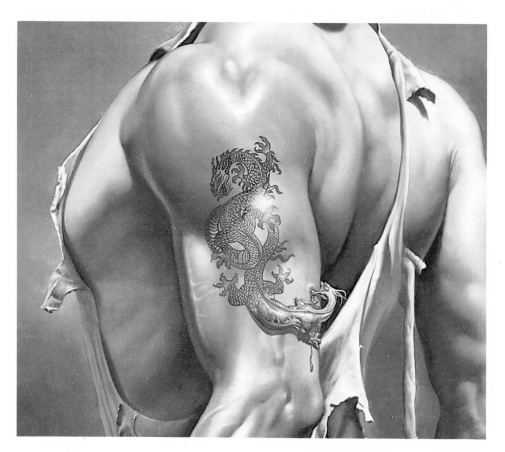

Dragon Tattoo from Mirage.

The Concept

The elements of a fantasy illustration need make no pretence of imitating life such as they must in, say, an illustration for a gothic, a mystery, or a novel. Fantasy engages the imagination to a much larger extent; the creatures portrayed may come partly or entirely from your head. And yet, to be successful, the scenes from your imagination must be convincing enough for a viewer to be willing to go along with you: to willingly suspend his disbelief and say, "*Yes, this could work*".

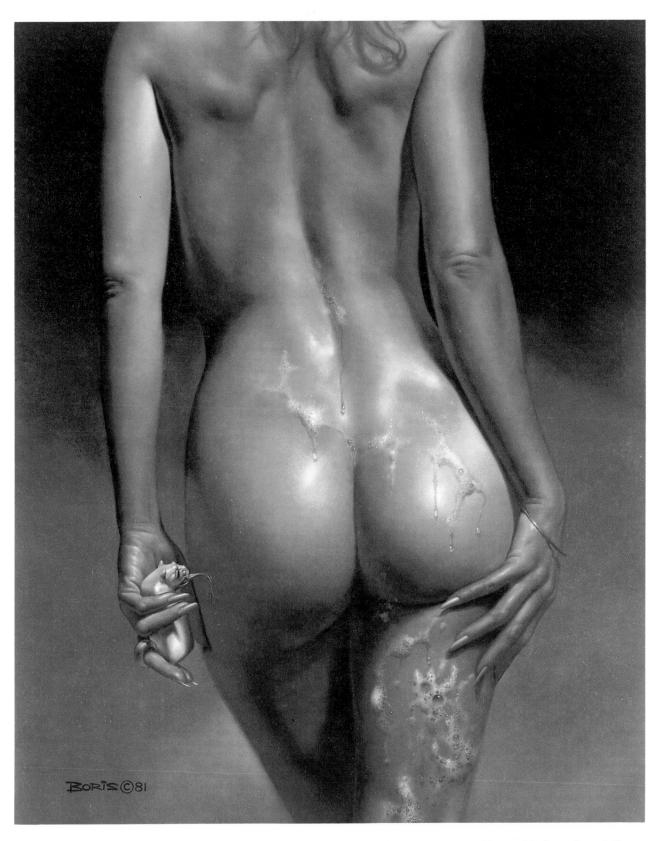

Counterfeit Lover from Mirage.

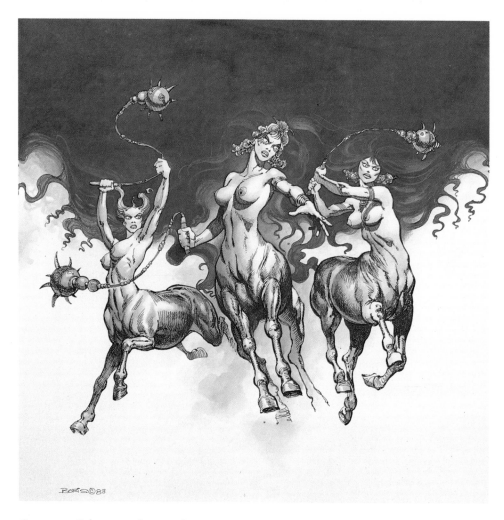

Centaurs, Colour rough unused.

How does someone begin to create these wholly imaginary pictures? The answer to the eternal question "Where do your ideas come from?" seems obvious at first. Naturally, they come from my head. Where else? Ideas come from one's head. It's true, when you set a manuscript to illustrate, you're likely to find descriptions in it. Still, it is up to the artist to interpret them. All those alien beings and landscapes come into being from what is, in fact, known to us. Existing life may be the point of departure, yet all successful fantastical creatures must relate back to it as traceably as vertebrates do to the single-celled amoeba. Muscles are what makes movement possible for the higher forms of living creatures. If you want to paint a combination animal/machine, let's say, there must still be a relation to existing animals and existing machines; the musculature, at least, must be plausible.

The immediate environment is a tremendous source of ideas for me: shadows, shapes, things that, as a result of being near-sighted,

Vampire, Unpublished.

I don't exactly see. It's pretty easy for me to reinterpret something twenty feet away which is already fuzzy. With a little push it readily loses its real contours and becomes something else in my eyes. If I start elaborating on what I don't clearly see, I can go in any direction. All I need is an existing starting point; my imagination takes over from there.

This odyssey of the imagination need not be a deliberate or controlled thing. It's much better when it's not directed, when I simply sit quietly and let it happen. In a sense, it's as though my ideas don't come out of me so much as I allow them to move in on me. The most important thing one can do to nourish the imagination is relax. I have noticed that when I specifically *try* to think of something, really strain towards an idea, very little happens. Whatever does happen is usually stilted and forced. If I relax and open the doors, so to speak, ideas do come.

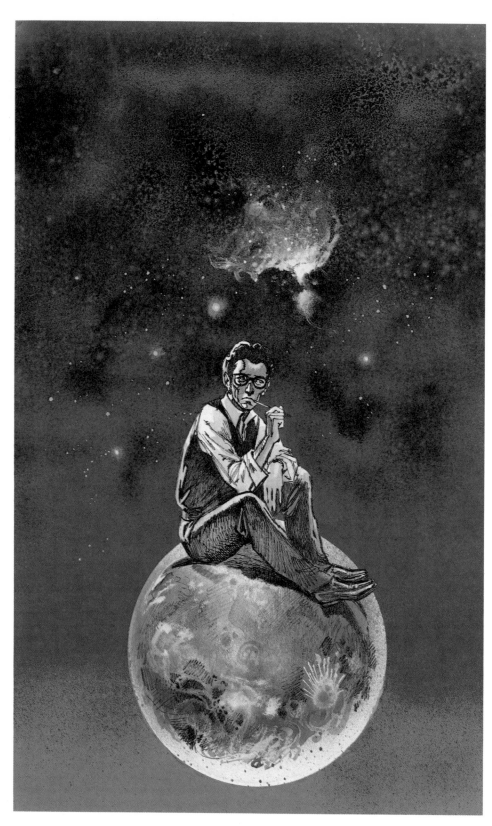

First sketch for Isaac Asimov stories, Unpublished.

Often enough, inspiration begins with the model. I see someone and I think: I would like to use this person for a painting; I would like to focus on this or that special feature of this person. From there I can evolve a character, an atmosphere, or an entire concept.

I once saw a young man at the gym I go to. He was an excellent bodybuilder, but the more notable quality about him was that he possessed not only huge muscles — a really fine development — but also a very boyish, almost child-like face, which presented a striking contrast with his physique. I stored this impression in the back of my mind, hoping that a job would come along for which I could use him. Then I was given a collection of stories by Isaac Asimov.

My original concept for this book's cover was of a young scientist type sitting on top of the earth in the middle of space. Subsequently I got a call from my client saying that although she liked the sketch, it was not exactly what she had in mind. What did she have in mind? Well, she was rather vague about that, but she preferred something with a more heroic feeling. As we were talking it occurred to me that, instead of emphasizing the human aspect of the stories, I might emphasize the mechanical.

It was then that I decided to do a robot — not the typical machine-like robot, but a more human one who would, nevertheless, have a superhuman appearance. At once I made the connection between this idea and the young man I had seen in the gym. The fact that his face was so youthful and his body so highly developed led naturally to the idea of keeping the roundness of the muscles and the distinctive shape of the body but making it metallic, chrome, really beautiful and shiny out there in the middle of space. I still thought of having him standing on the earth, but as I worked, the earth changed into a simple globe. It also became shiny, like glass or chrome.

So, you see how the concept changed from the sketch of the robot that I started out with to the finished painting. With the use of that man as the model, the robot became an almost superhuman figure, spinning nebulae out of his bare hands. His face is nearly expressionless. Yet there is a suggestion of childlike wonder and joy at what he is doing: there he is in the middle of space, fascinated with the beautiful things he is creating. In this case, the "model" was just perfect, and the concept owed a great deal of its development to his physical characteristics.

Of course the concept may originate in a more general way than with the model. I may simply think: It would be nice to do something metallic; it would be nice to do something fluffy; it would be nice to do something in which I can concentrate wholly on the figure because the background would be negligible or, vice versa, in which I can concentrate mainly on the background because the figure is inconsequential.

Most often, however, the concept is established by the manuscript to be illustrated or by the movie for which a poster is to be made — by the product to be sold. In the case of a book there is, first, the manuscript. There is an old saying that one shouldn't judge a book by its cover. But often enough a book is bought precisely because of its cover. Therefore, as an artist, what one must look for in a manuscript is a scene that is representative of the book, perhaps one with plenty of action or one that is, for its colour or subject, quite eye-catching. After all, there are hundreds of books on the bookstore shelves and the successful cover should draw the prospective buyer like a magnet.

Some authors are very descriptive and make the task of selecting a visually effective scene relatively easy. *The Lavalite World* is a good example. It is a book of adventures and consequently presents any number of action scenes involving the hero, the heroine, and the monster or villain. To show the hero and heroine riding a tree trunk into battle was, to my mind, colourful and unusual enough to evoke any browser's interest in the book.

Some authors are less visual in their writing. They write with less attention to detail and their imagery is more abstract. In such a situation one has to capture a feeling, something representative of the story rather than a particular scene or incident from it. This feeling must then by expressed in visual terms in order to convey an immediate sense of what is going on in the book. My illustrations for *Enchantment*, which my wife Doris wrote, exemplify this.

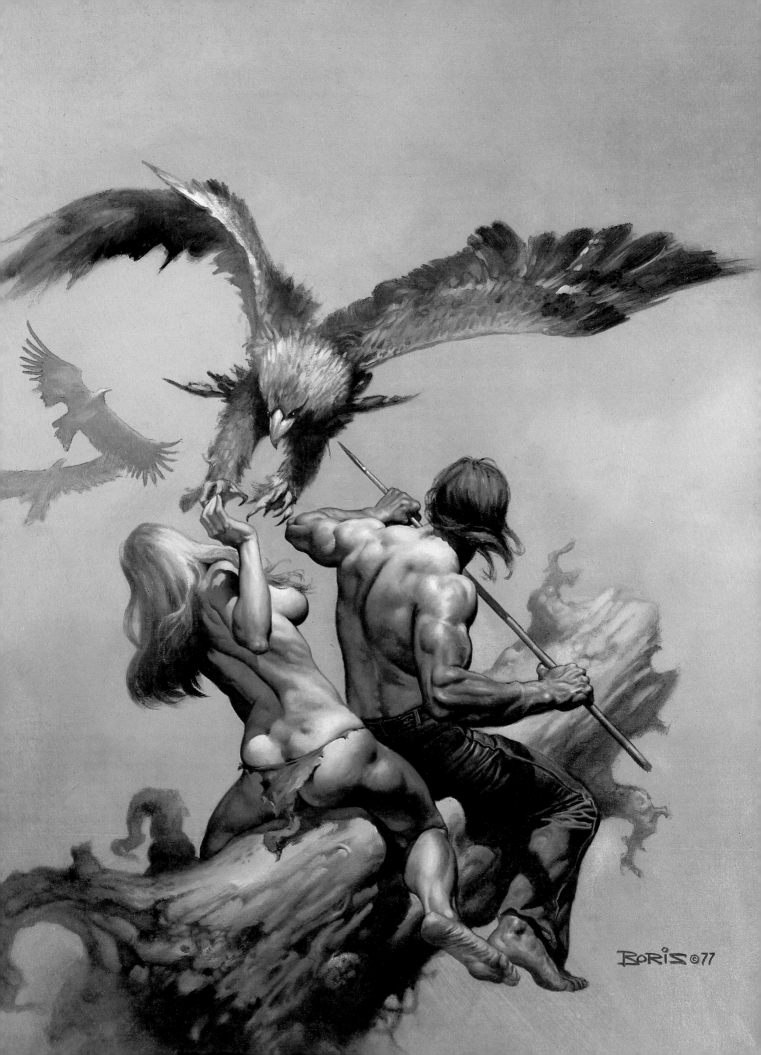

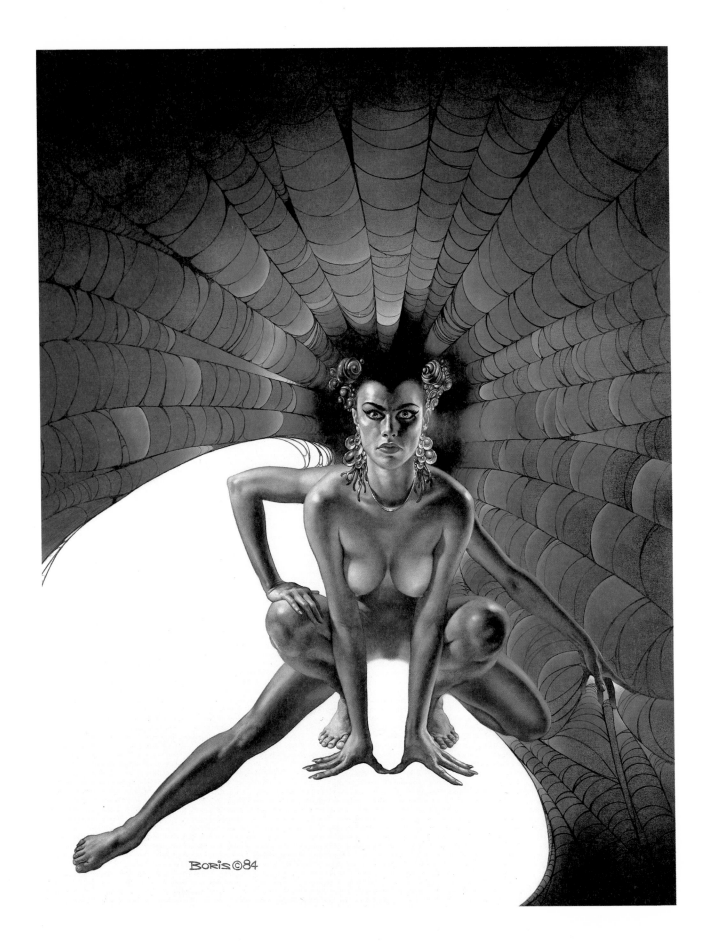

BORIS ©84

The painting for "Web" does not represent a particular scene from the story. It is simply a depiction of the way I experience a spider woman. I began with the question: What typifies a spider? It has eight legs. But I didn't want to paint a totally unappealing woman with eight hairy legs. I wanted a woman who was sensual and sexy-looking, but at the same time menacing, and who would still evoke the feeling of a spider — perhaps with a spiderweb around her.

The painting that was done for *Heavy Metal*, however, was not inspired by a manuscript or anything more than the title of the magazine itself: HEAVY METAL. I began with the idea of something metal, a heavy metal. A safe came to mind. The door of a safe which, to me, was quite representative both of "metal" and of "heavy". From there followed the image of a bank vault. Yet this was a fantasy painting that I was going to do. What did fantasy have to do with a bank vault? I decided to put it into space; a heavy metal bank vault floating in outer space. Still, something fantastical had to happen. What if something is inside there, I thought. What would have to be locked behind such a door? Some kind of creature, obviously, that has to be kept from escaping. And what if the creature has been pounding at the door? What if the creature has a metal hand that it has been pounding and pounding the door with and has finally broken through? The first picture that flashed through my mind was of some powerful and monstrous creature. But that would have been a bit too ordinary. So I made it incongruous: a kind of wild-looking woman instead of a creature, not all that physically powerful in appearance but with a crazed look. She not only had the metal hand but the wild eyes and the wild red hair. All these elements brought together in a painting should really make the viewer stop and say: Look at that! What's going on there!

Web, Ballantine.

The Micronauts, Bantam.

Molly Hatchet, CBS Records.

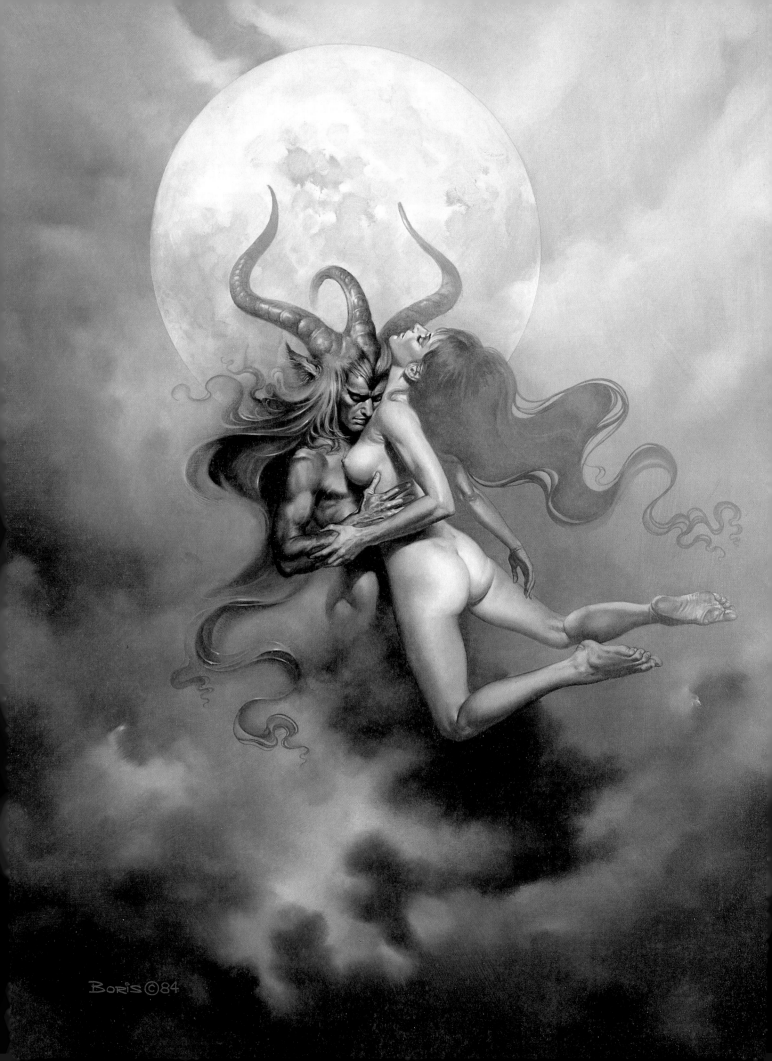

Seeing

The secret of learning to draw is in learning to see. The ability to paint is the ability to translate three-dimensional objects into two-dimensional ones. What you primarily have to learn to see is how the spaces relate to the masses. Let's say you are working from a model who is posing with one hand resting on a hip. Not only must you consider the shape of the arm itself, but the space between the body and the inside of that arm, the space around the body and the arm, and how all these elements relate to one another.

I often see the students draw a perfectly reasonable head and go on to do a torso, arms and legs, all of which get smaller and smaller, resulting in a tiny body with a huge head. How can you correct this? If you think in terms of how the different parts of the body relate, not only to each other but also to the surrounding area; if you are aware of the spaces between the parts of the body and outside the body and of the distances between feet and knees and chest, then you really begin to *see* and start to get your figures in proportion.

Full Moon, Ballantine.

Once you have grasped this you will understand how to create the illusion of depth: how you do see the things that are closer to you as being larger than those that are farther away; how a hand extended toward you does seem larger than if it were just at the model's side. It is the *illusion* of its greater size you must aim for in your drawing in order to create the illusion of depth. In the same vein, the things that are closer to you are sharper, the things that are farther away are blurred. In terms of colour, what is closer is more vibrant, more vivid; what is farther is less so and tends toward the greys. In terms of contrast, what is closer has more contrast, what is farther away has less. All these seeming realities are illusions created by the varying volumes of air and dust between you and what you are looking at. These influence how you see colour.

If you have a flat surface, it appears to absorb the light evenly and its overall colour also appears uniform. If you want to create the illusion of volume or shape, you can put a shadow on one side, a highlight on the other. It is the effect of all this that you imitate in order to give the illusion of depth, volume, shape — in short, the

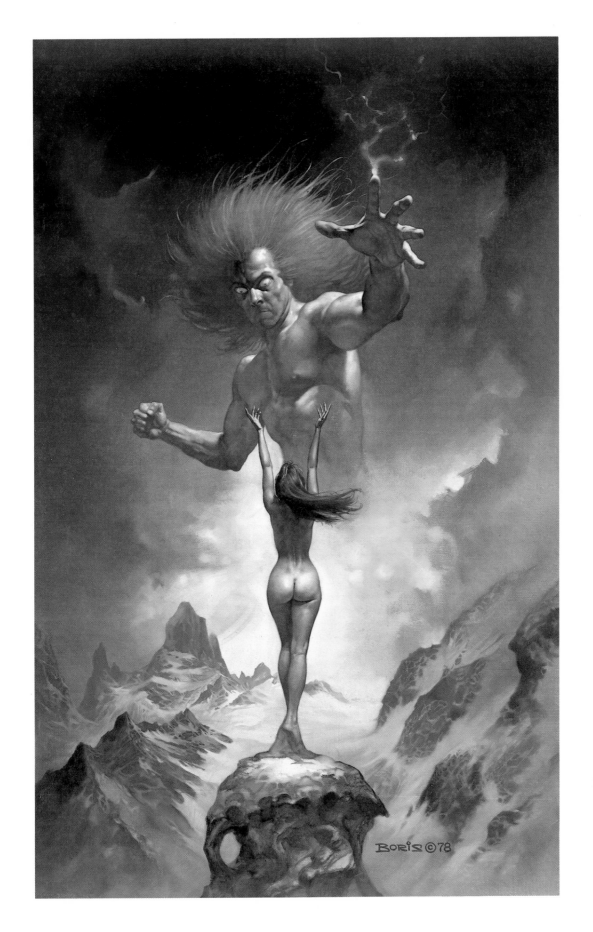

illusion of reality — to your work. All these illusions are what you learn to see.

If you want to create the illusion of a bright day as opposed to a cloudy day, you must "see" what it is that gives the impression of brightness. Is it a blue sky? Not necessarily. You can do a painting with a grey sky but have your scene lit in such a way as to make it appear sunny. For a bright day you must make the shadows sharper, the highlights more intense, and use fewer in-between values. When the sun is shining brightly, its reflections from the ground bounce off objects in varying degrees, further influence your perceptions of their colours.

The eyes are lenses, just like the lenses of a camera. What they perceive is only a combination of light and shadow and colour. If everything around you were the same colour and lit perfectly evenly, you wouldn't see anything. What makes the difference in how you see things — glass, metal, fabric, flesh — is how the light reflects off it. That is basic, and it gives you the key to creating the illusion of different textures, different surfaces.

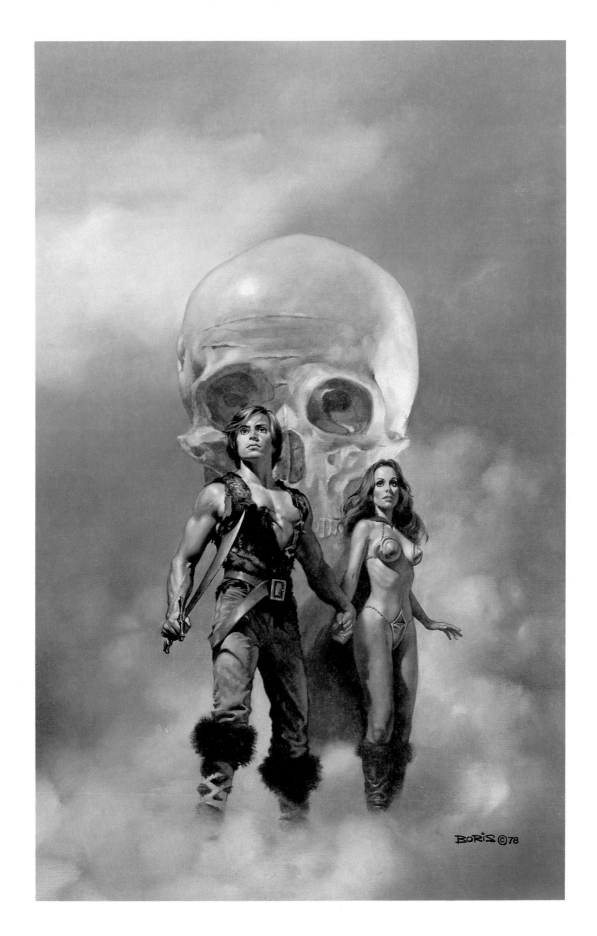

31

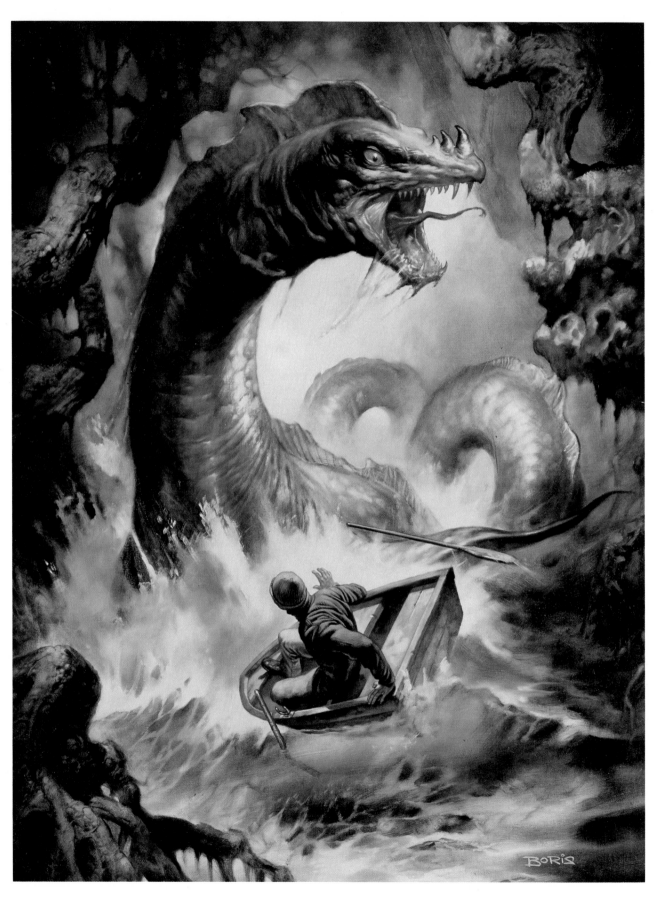

Illustration for Busch Gardens.

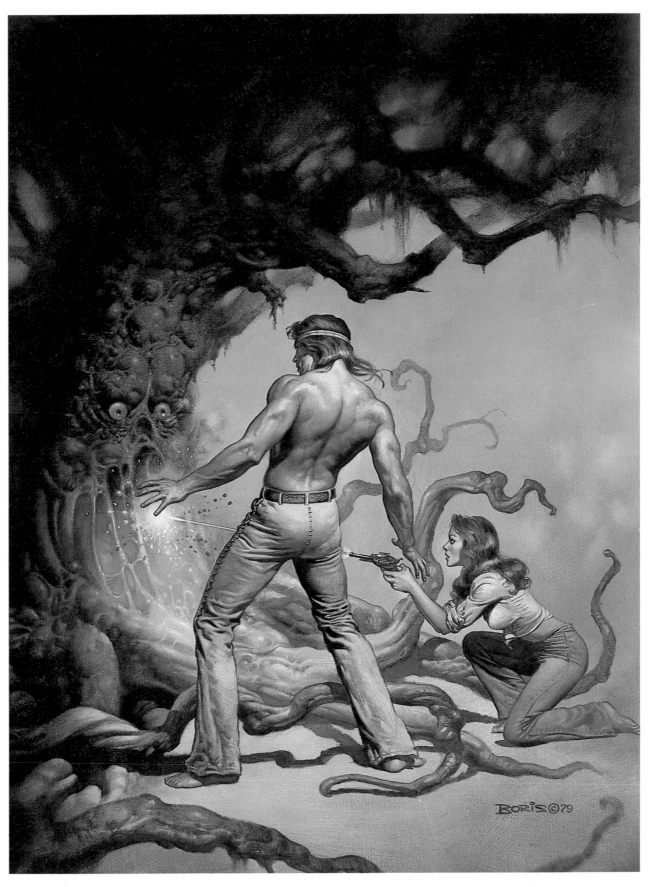

Tree of Death, Doubleday.

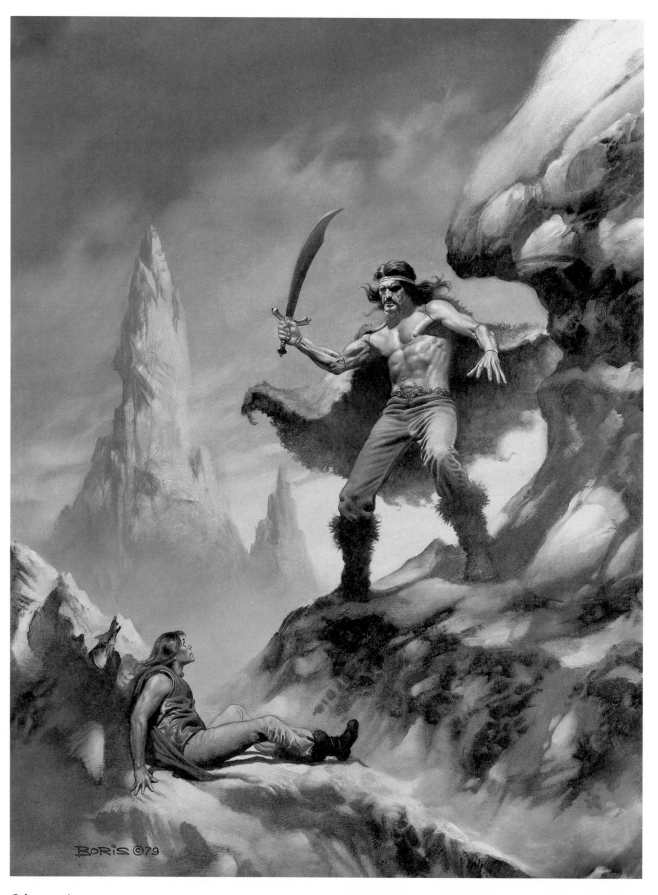

Colossus, Ace.

Lord of the Wolves, Ballantine.

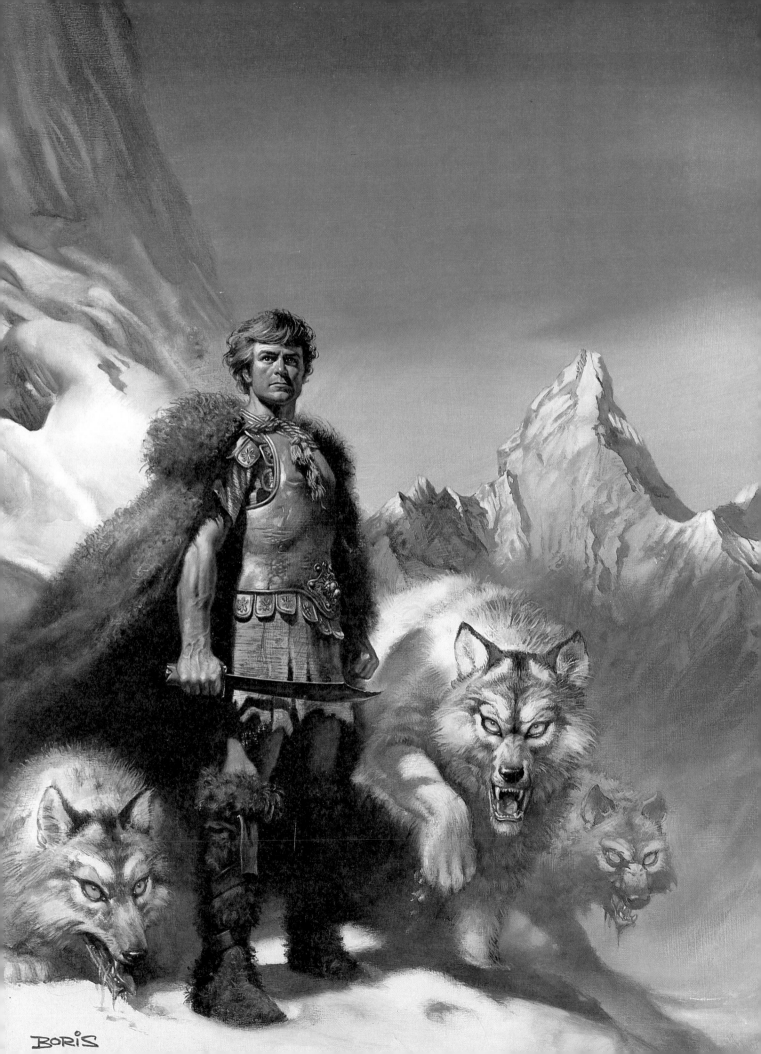

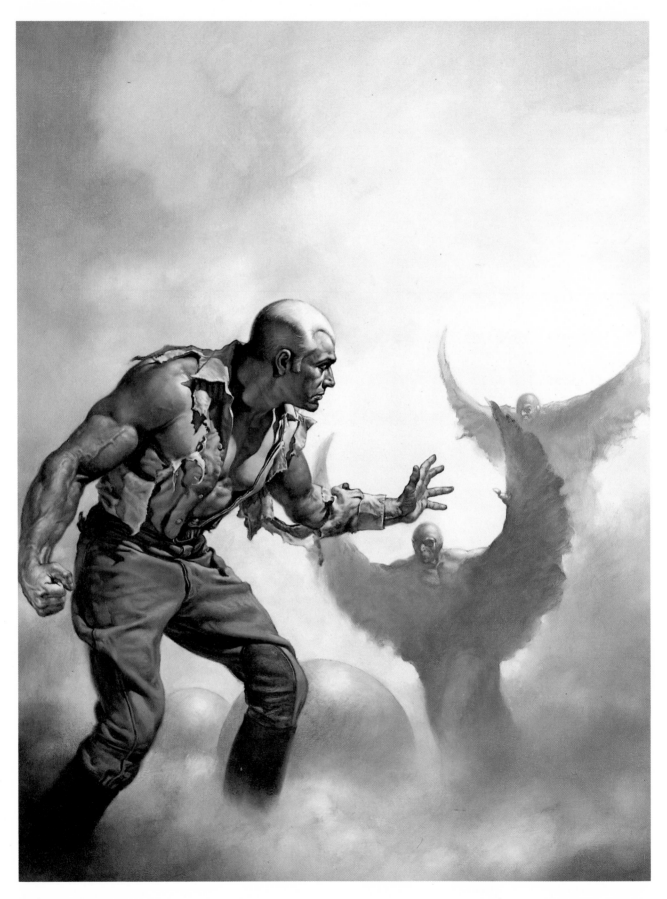

Red Terror, Bantam.

The Mountain Beast, Bantam.

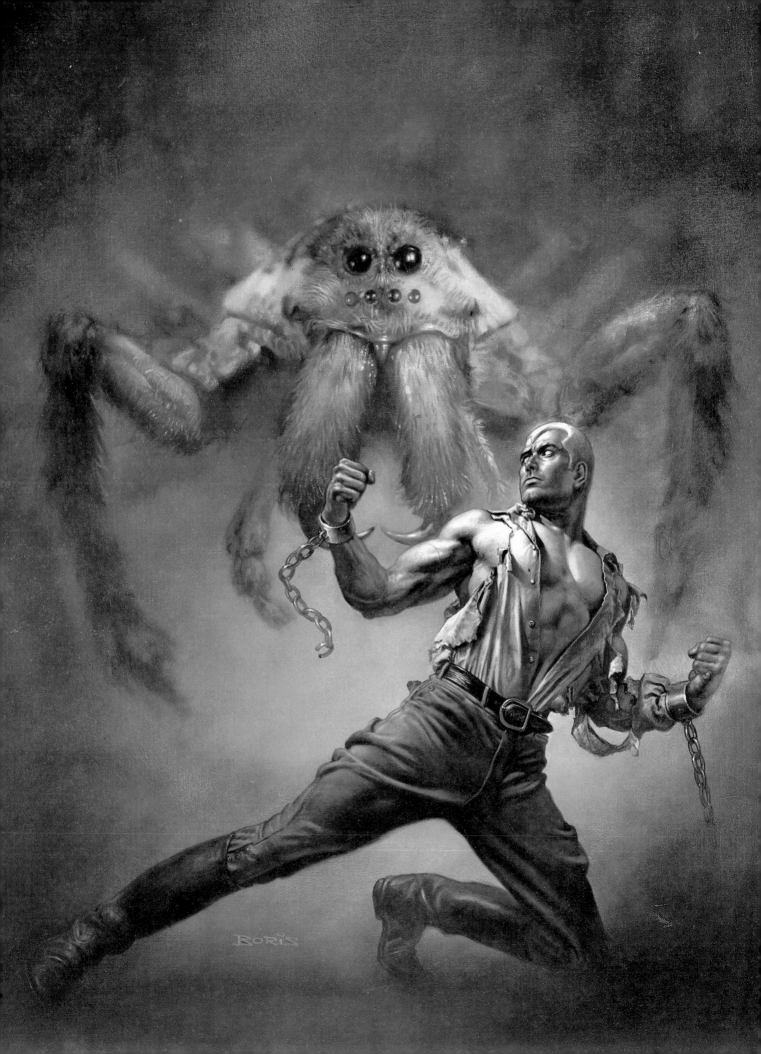

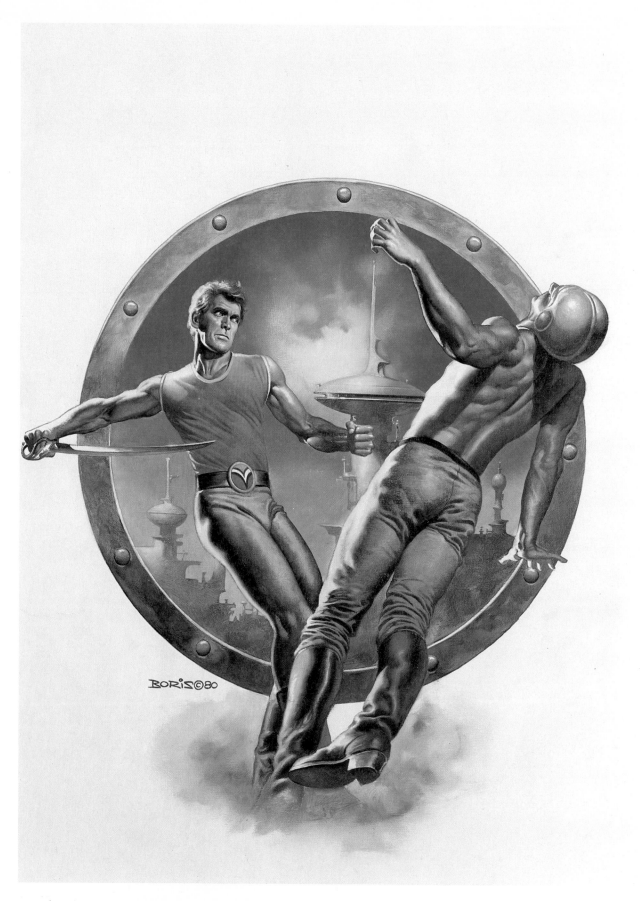

Sword Fight, Ace.

Android, Ace.

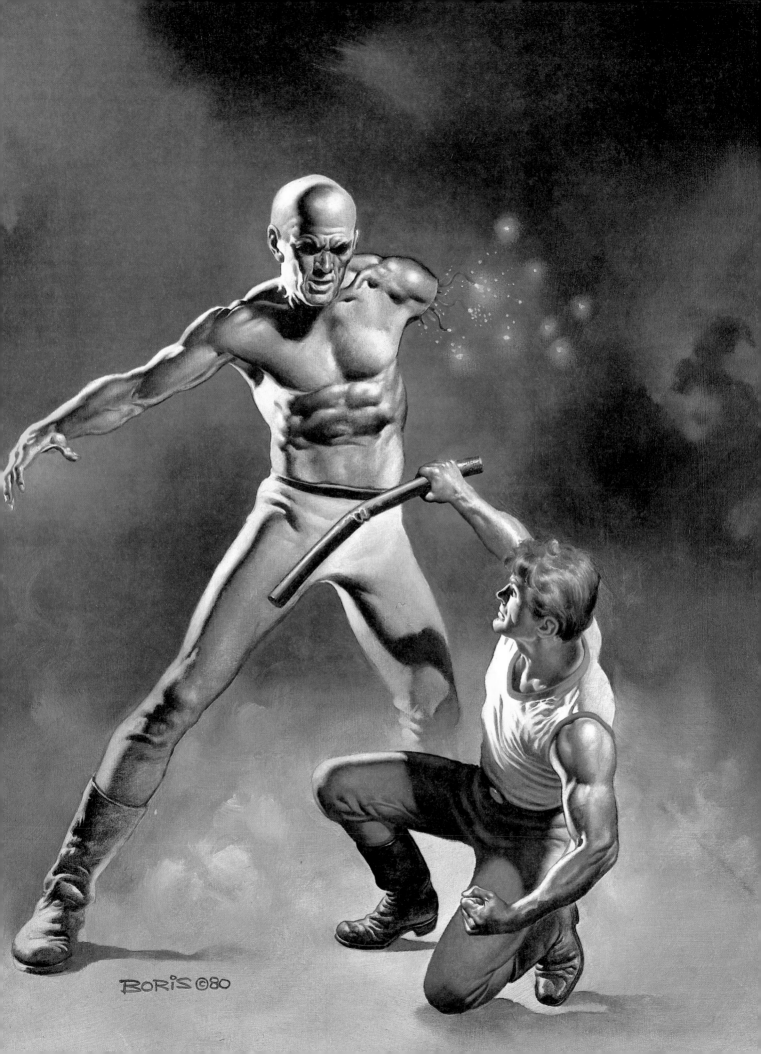

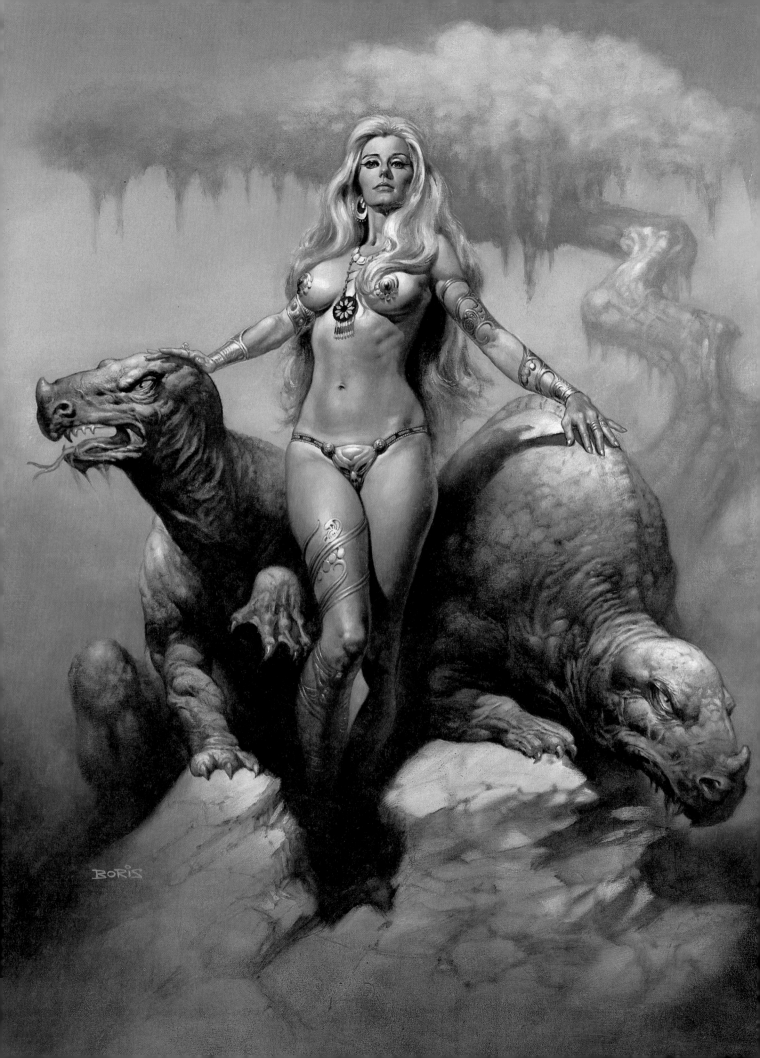

Skin Tones

I am frequently asked how I paint skin tones. There is no one way to do skin tones. There is certainly no formula. To begin with, you have to consider the given scene and situation.

If people are depicted outdoors, their skin should appear to have a different tone than if they were shown indoors. When painting skin, some artists have a tendency to work with the same tones from head or foot. If you look at a human body, however, — in fact, if you just look at the face — you will see that it is not evenly coloured. In the area around the eyes, for example, where the skin is thinner and the veins are closer to the surface, you may see more blues and purples.

I work in terms of what is most effective. By that I mean what one is *used to seeing*. The skin tones in my paintings look "real" because they look like what you expect, what you are used to seeing.

Primeval Princess, Portal Publications.

Let's say you're doing a painting of Tarzan. Supposedly, Tarzan is out in the jungle from morning to night, so it is not unreasonable to imagine that he has an even, allover tan. To paint him that way would not only be visually uninteresting, it would also look less authentic, simply because we don't usually see people with perfectly even tans. We see people who do not go naked all the time but who spend a good deal of time indoors and have their bodies covered to a greater or lesser degree. When viewed without their clothes, their bodies have lighter and darker areas. This, then, must be suggested in a painting to present a greater illusion of reality, even on a Tarzan-like figure.

The hips, the breasts of women, wherever the skin is thinner, more delicate, will have shadings of blue. The shoulders, arms, and particularly the elbows and knees will be darker than the rest of the body. This is also true for the skin around the knuckles and the fingertips. The areas around the toes and heels are pinker. The sides of the feet tend to be lighter than the tops of the feet. The more

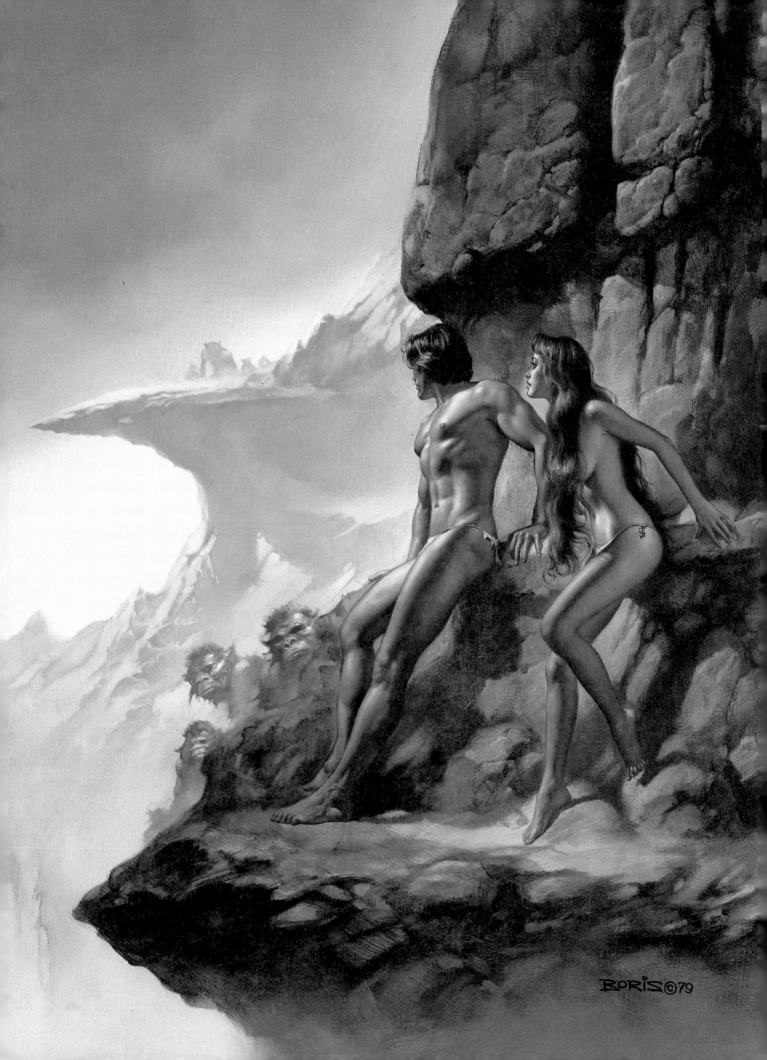

aware of this you are, the more success you will have in creating the illusion of real flesh.

Another point to consider when painting skin tones is what your subjects are doing. If you are painting a figure engaged in battle, its cheeks should be rosy. If the blood is rushing through a person's system, certain areas of the body will appear to be flushed.

I like to use a reflection of what is around in the shadow areas of the skin. If the scene has vegetation, it's nice to use some green on the skin as well as some warm colours to offset the coolness of the green. If it is a snow scene, I like to use blues and purples on the skin to give the impression of cold. In a snow scene, the skin of any given figure should appear lighter than the same figure in a tropical setting. In the work of Bouguereau, a painter of the Romantic school, you see very grey skin tones which are warmed up with cadmium orange in the shadow areas — under the nose and chin, for example.

When rendering skin, it's important to be aware of its softness and flexibility. Too many artists paint skin that looks like plastic. What is it that makes anything look soft? Not only its softer highlights, but its give. If someone is wearing a belt, for instance, you see its effect on the flesh above and below it, even if the person is slender.

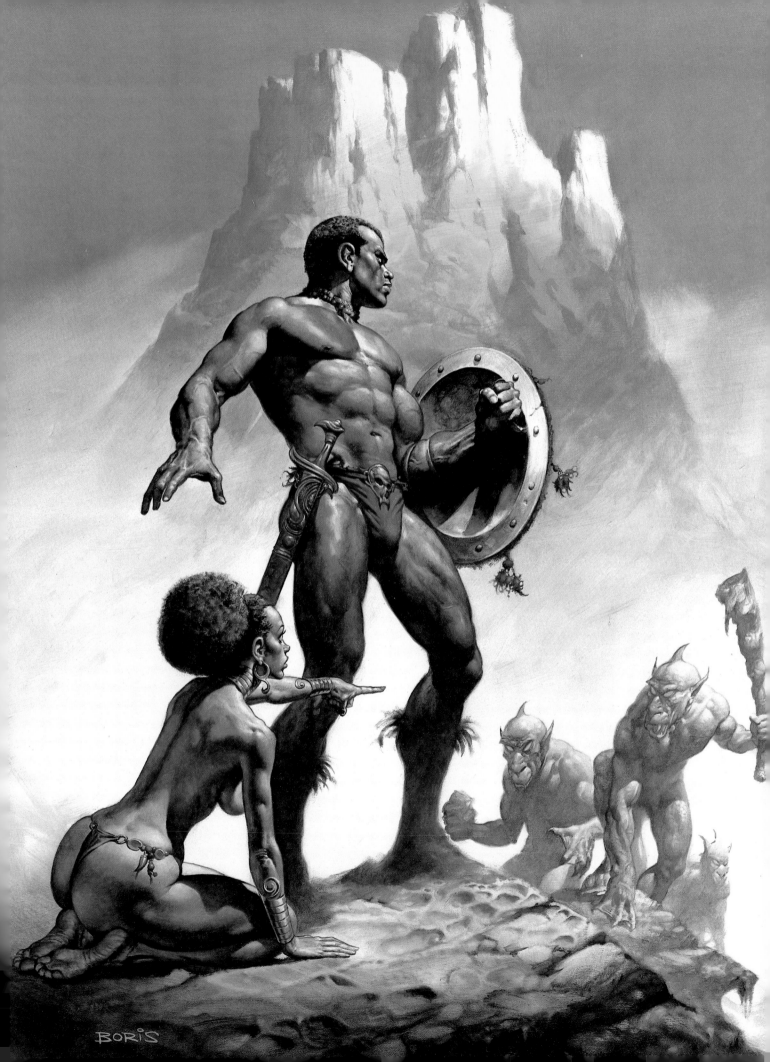

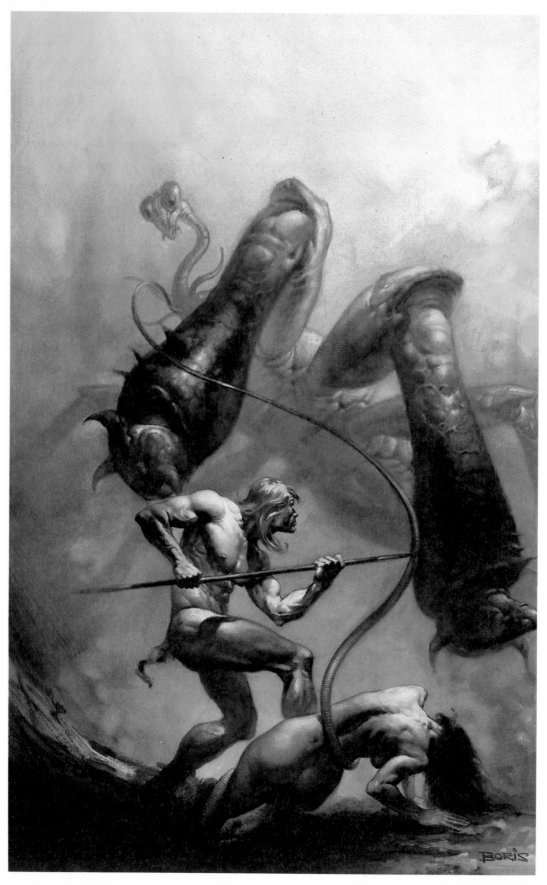

Of Men and Monsters, Ballantine.

Last Battle, Portal Publications.

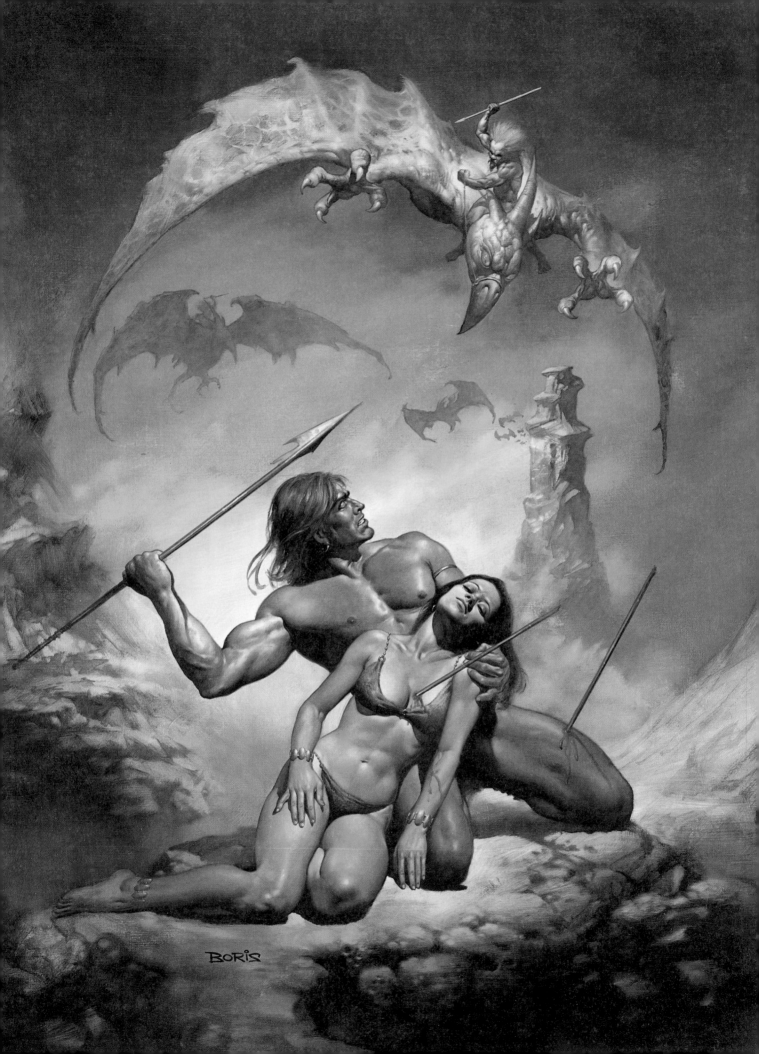

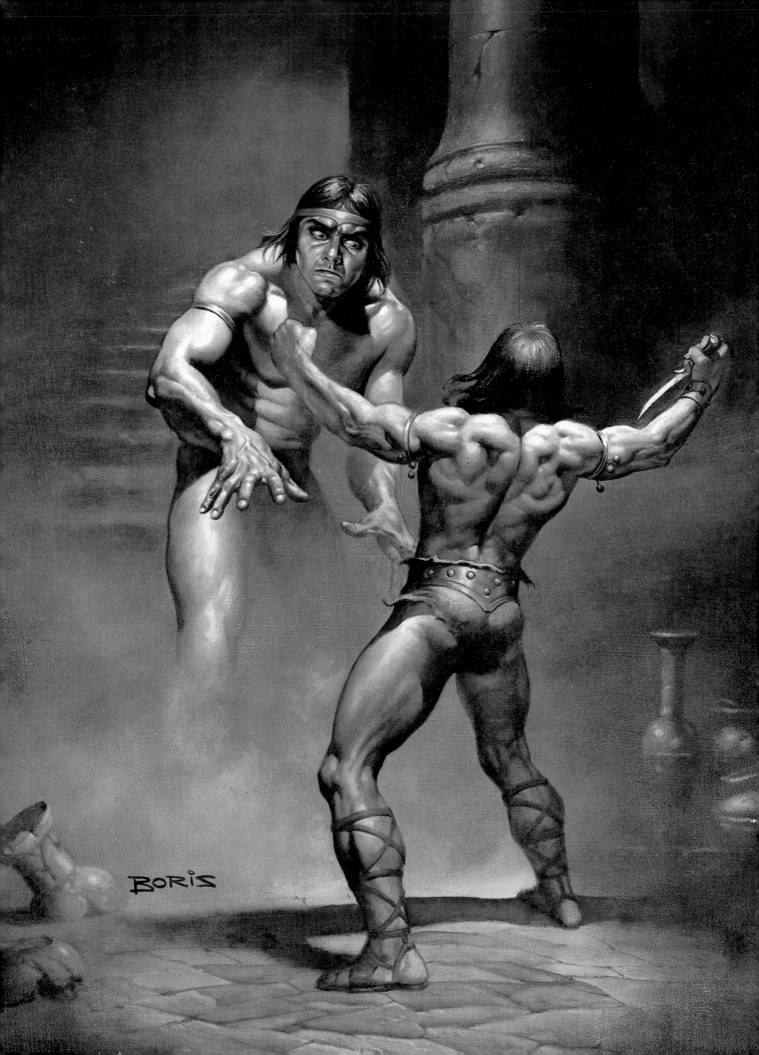

The Models & Photographs

Today, 99 per cent of all illustrators work from photographs. It saves time and money. Students have asked me if this isn't cheating. First of all, you have to define what cheating is in the context of any given project. It is not as though specific rules are set down for the production of an illustration, and if you don't follow them, you are cheating. You must do whatever facilitates the process of getting the painting finished. This is especially important when you have to deal with deadlines.

A commercial artist creates a painting in order to get paid for it. It follows naturally that the faster the painting is completed, the more paintings can be done and the more lucrative the whole business becomes. But Old Masters did not work from photographs, students argue. I'm quite sure that if cameras had been available to the Old Masters, many of them would have preferred working from photographs rather than having the model shifting and moving and falling asleep, or whatever. To produce a painting, even under the

Iron Warrior, Ace.

49

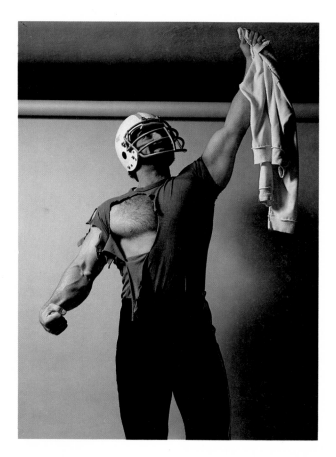

Polaroid of footballer model. *Illustration for Playboy Magazine.*

best of circumstances, takes at least several days to a week. It would be expensive as well as tedious to have a model hold a pose for that length of time.

There are advantages to using photographs. But there are disadvantages, notably that you lose the third dimension when you are working from a two-dimensional reference. To compensate for this loss, I work from life as often as I can and use what I have learned to enhance my work from photographs.

Sketching from life models is essential. When I was teaching at an art school and requested models for my class, the Dean said, "The people who take this class want to do fantasy illustration. There are other classes they could take for life sketching." My point, however, was that you cannot run before you are able to walk. Learning how to see and developing the skill to translate what you see on paper or canvas is tantamount to learning to walk. One of the most valuable

51

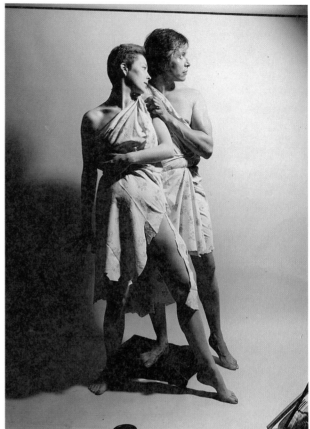

Talisman.

Polaroid of Talisman models.

lessons I learned in the class I took with Jack Potter was the importance of just looking. He constantly reminded us to spend more time looking and seeing than drawing.

Of course, the beginning artist should draw only what he sees. To use the actual reference as no more than a starting point for the evolution of something wholly unique must come later. To give too much freedom to someone who doesn't have much knowledge is to create unnecessary problems.

I use a Camera Lucida machine to trace the photograph at the size I need it. This also speeds up the process of doing a painting. It doesn't mean that I can't draw. Nor does it mean that I slavishly copy the photo. A considerable amount of alteration takes place. A camera lens distorts images to a certain extent — if I traced a photo of a model exactly, I would end up with a short, squat-looking figure.

As an artist, you should be able to make the alterations necessary for a more aesthetic or pleasing effect. You can exaggerate the action, the movement, and the poses in order to suit the purposes of dramatic effect, composition, and the like. You may also use a combination of photos to arrive at a single final figure. In a shooting, you don't just take one picture but several, and you may want to combine elements from different pictures to end up with a desired image that is not wholly represented in any one of them.

While creating the creatures for my paintings, I have the tendency, even when I do animal-like ones, to think in terms of human qualities. My creatures rather typically have human-like arms or legs. I do combine photographs of humans and animals to achieve this effect. Of course, I only follow these photographs in a very general way. I rarely attempt to do a portrait or achieve a faithful likeness of my model, even when I am painting humans. In certain instances I may not consciously set out to make changes. They just happen as I am working. Yet, I deliberately modify certain aspects of a photo that I don't feel add to what I am doing.

I obviously did not have a metallic model for the painting of the robot for the Isaac Asimov stories. I used the basic shape and shadowing of my human model and added to it the understanding I have of how metal reflects light. I did gather some pieces of chrome and study how the light bounced off them.

The black horse in the painting of the mounted warrior woman with the attacking creatures flying toward her is an example of where I sacrificed authenticity to achieve an effect. I exaggerated an action and altered anatomy to heighten the sense of drama and movement. It is obvious that if this horse were flexing his neck as much as he is in the painting, his head would not be coming forward but would be touching his chest. I felt, however, that by exaggerating the motion of the horse and making his head come forward I gained a sense both of the abruptness of his halt and of how strongly the rider was urging him forward. The forward position of his head reflected this command, this urgency, even as his body resisted it in the stiffness of his front legs and the exaggerated bend of his hindquarters. While my knowledge of horse anatomy did come into play, I altered what I know to suit my artistic purpose.

53

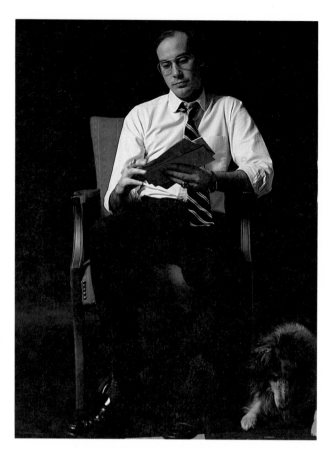 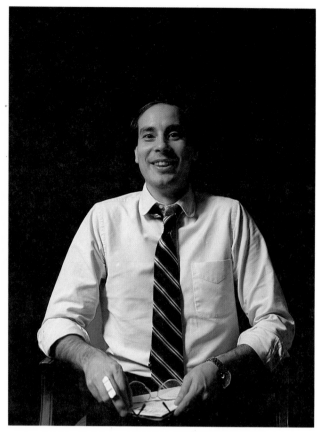

Polaroids of "Games" model.

Illustration for "Games" magazine.

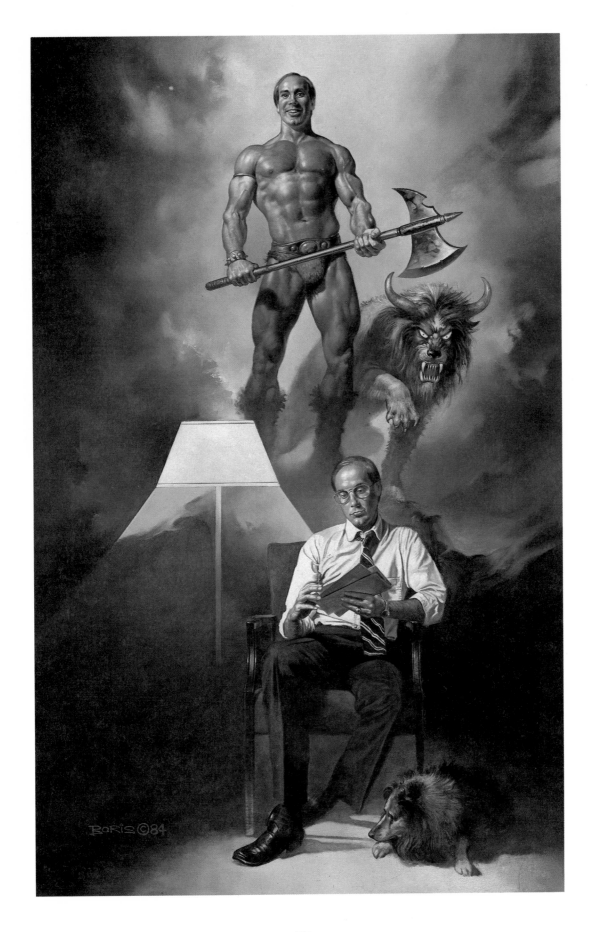

Pencil drawing.

Polaroid for Gryphon's Eerie.

Gryphon's Eerie, Tor.

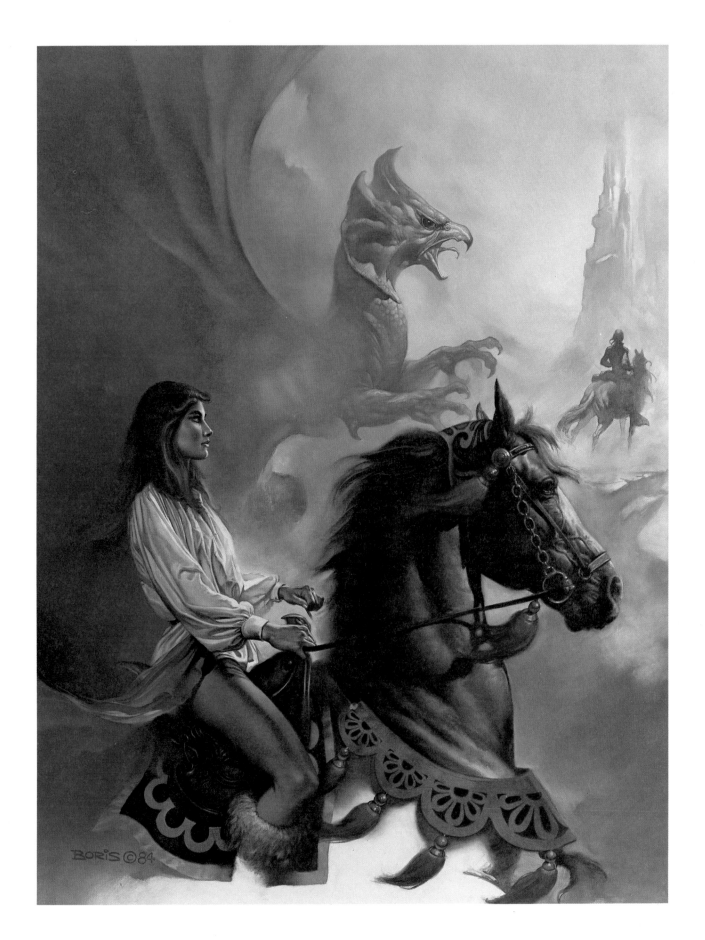

BRIS ©84

Polaroids for the monster in The Victorious.

Pen and ink rough for The Victorious.

Polaroids for the figures in The Victorious.

The Victorious, Tor.

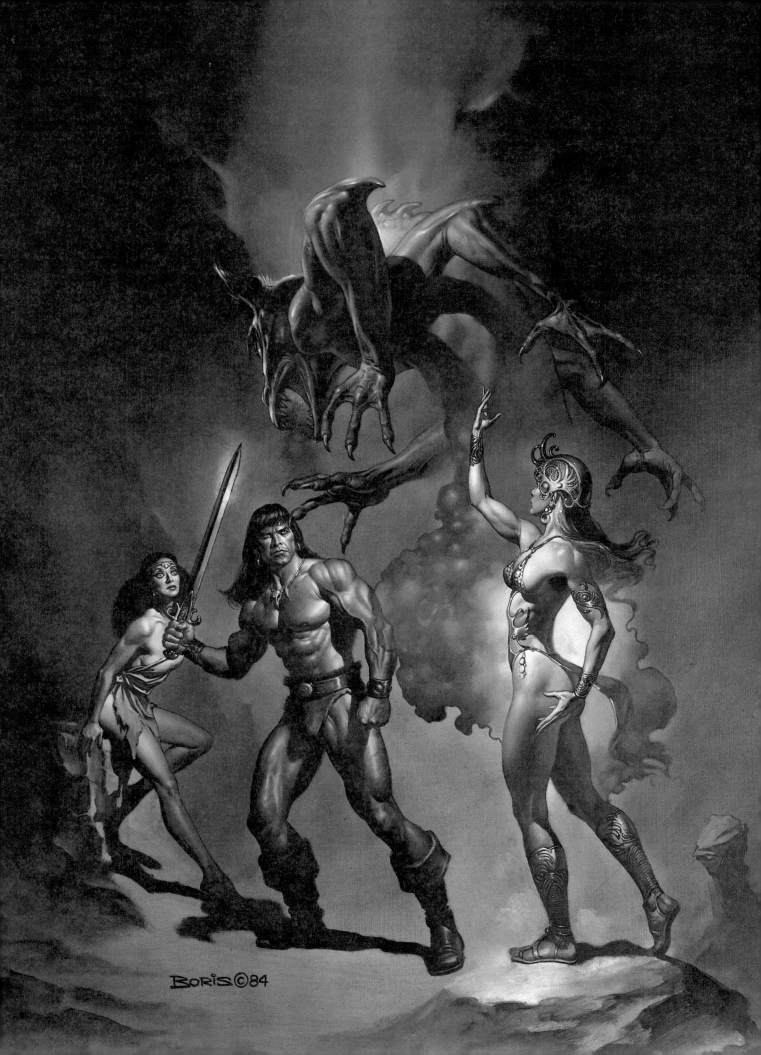

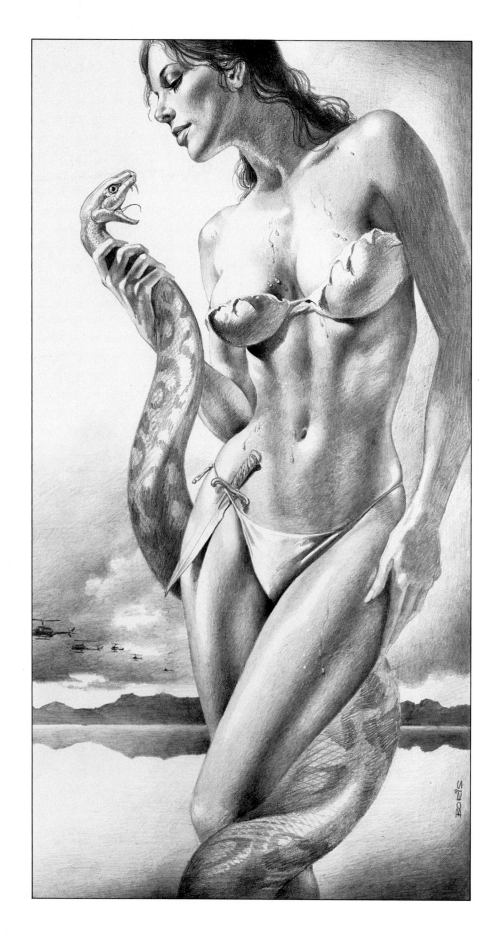

The Rough Sketch

In developing a rough sketch, I like to think in terms of solids before defining anything. I begin with masses or lumps: lumps to the right, lumps to the left, lumps and an extension, lumps and a tentacle, and so on (pencil sketches on tracing paper that show an evolving creature). I think of shape, negative space, light and dark — just very basic and amoeba-like.

Once I have that, I start thinking in terms of motion: What kind of motion would this amoeba have, and where am I going with this amoeba? Before I have a specific shape, I have a general shape. From there I start polishing.

In designing the monster on the pencil tracing, for instance, (it was to be a belt buckle), I began with the shape of an 'S'. I saw the completed thing in my mind, more or less, but the process of getting it down on paper was a different story. The mind somehow sees things differently from the eye. In my mind the thing seems to be in motion, and before I have a chance to grab it and put it down it has moved. It's like trying to sketch a figure in motion. You never get the whole thing, only a small part; you grasp an instant. It is the accumulation of a multitude of instants that comprises the final whole.

So I do tracing upon tracing. First I sketch my mass, then I sketch my elements, then I start defining. The cleaner and more defined it gets, the less it has. The rough, quick, loose, undefined basic shape of the beginning relates more to the mental idea than the final sketch.

Pencil drawing for James Bond film "Never Say Never Again", Warner Brothers.

Early pencil roughs of athletes, various projects.

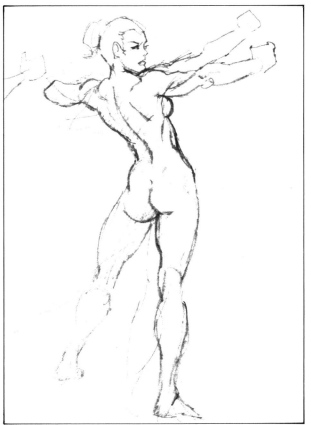

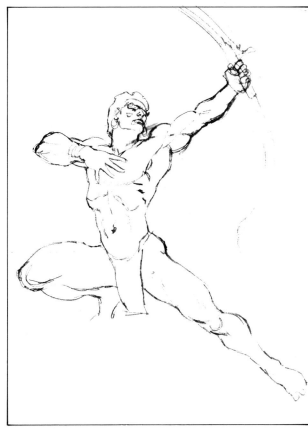

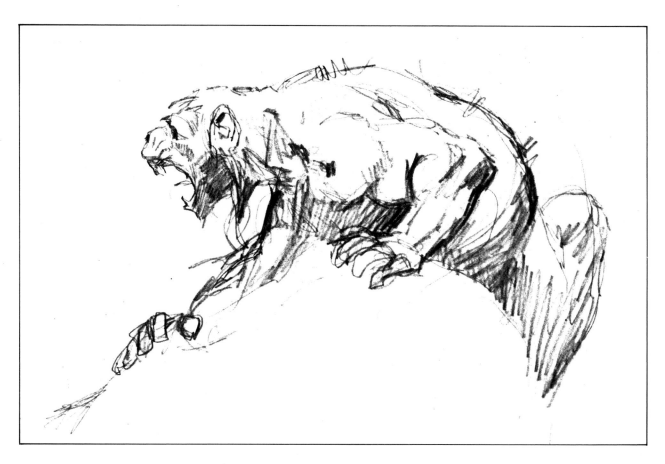

Pencil roughs of mythical beasts.

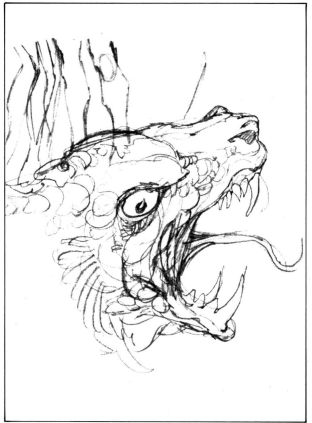

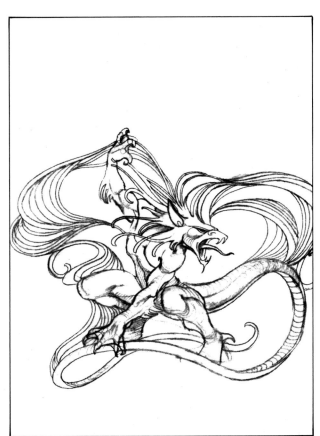

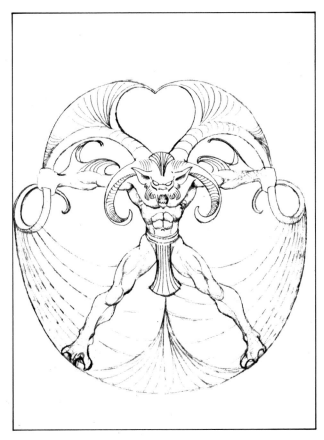

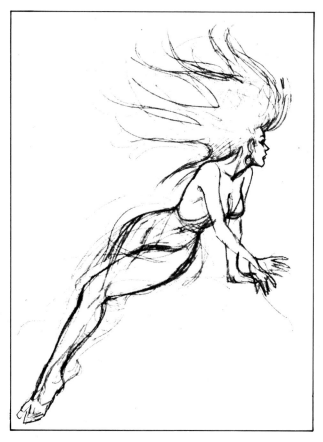

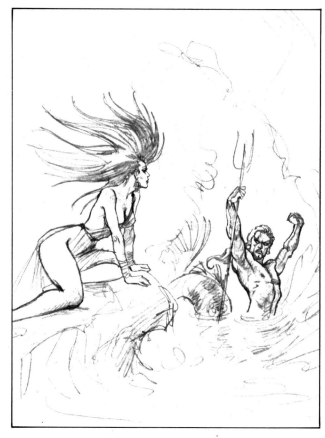

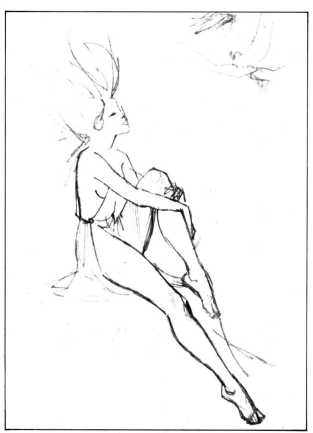

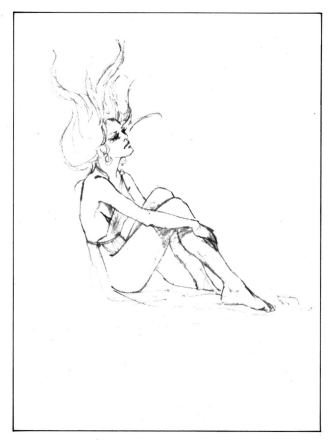

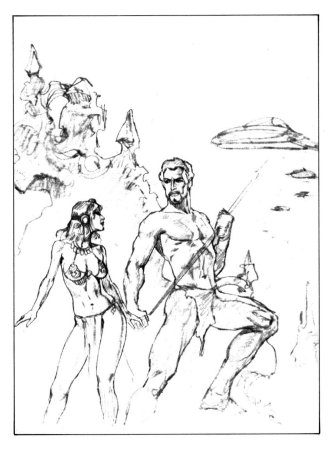

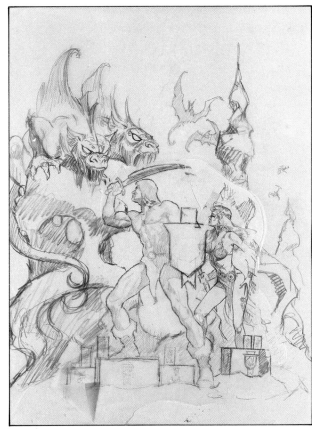

Development of pencil sketches up to the final layouts
for a painting.

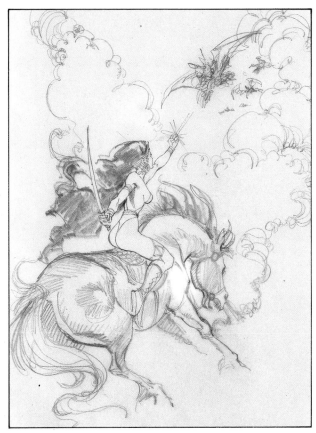

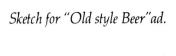

Sketch for "Old style Beer" ad.

Sketch for "War skull of Hel", Warner.

Pencil sketches.

Scarecrow Angel, Ballantine.

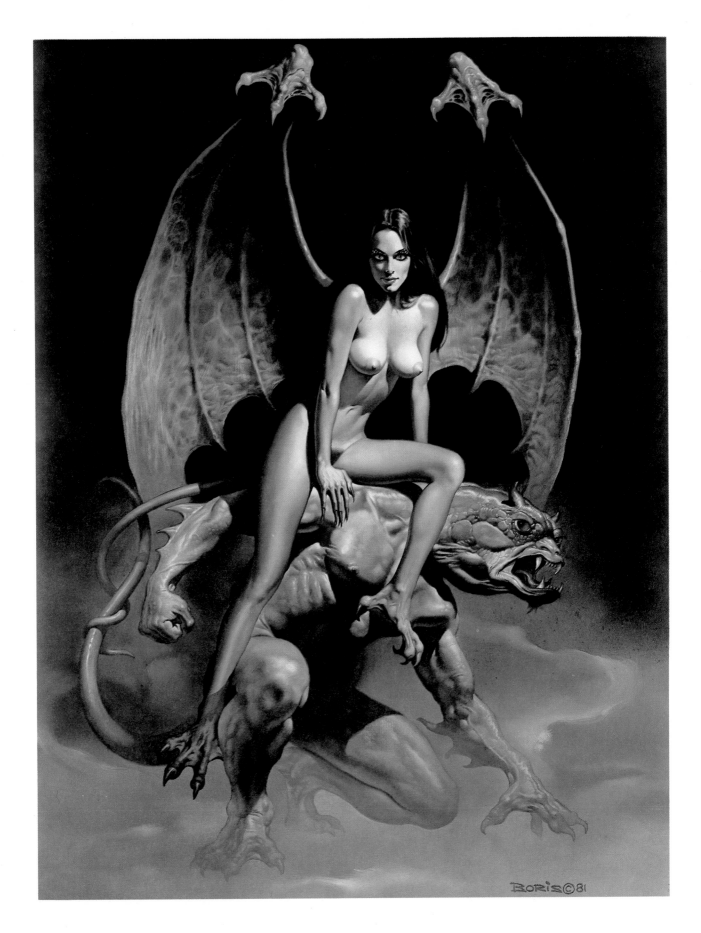

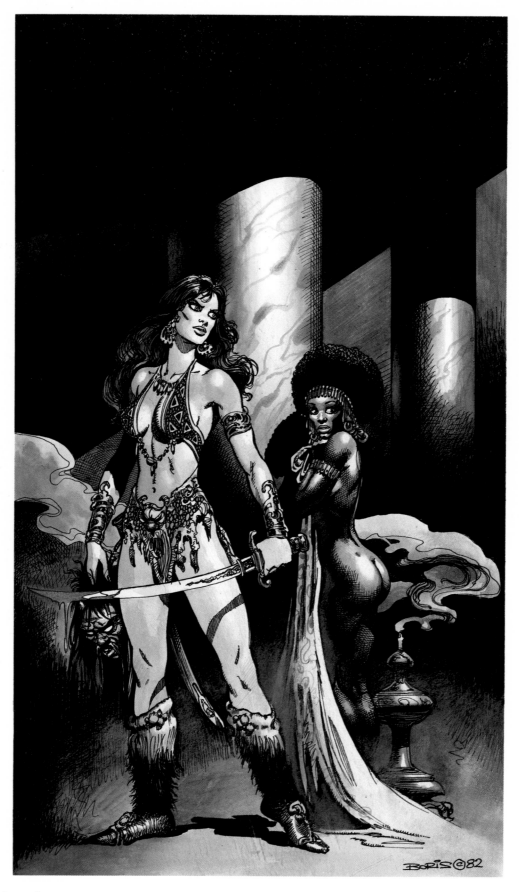

Coloured ink rough.

The Executioner, Daw.

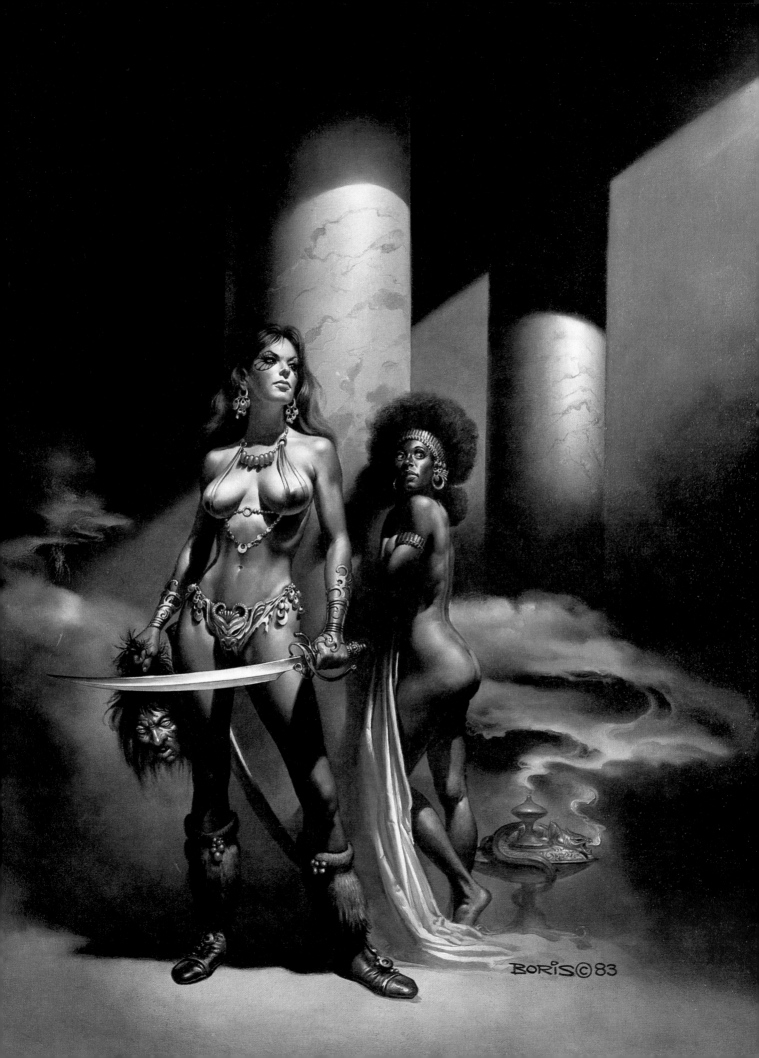

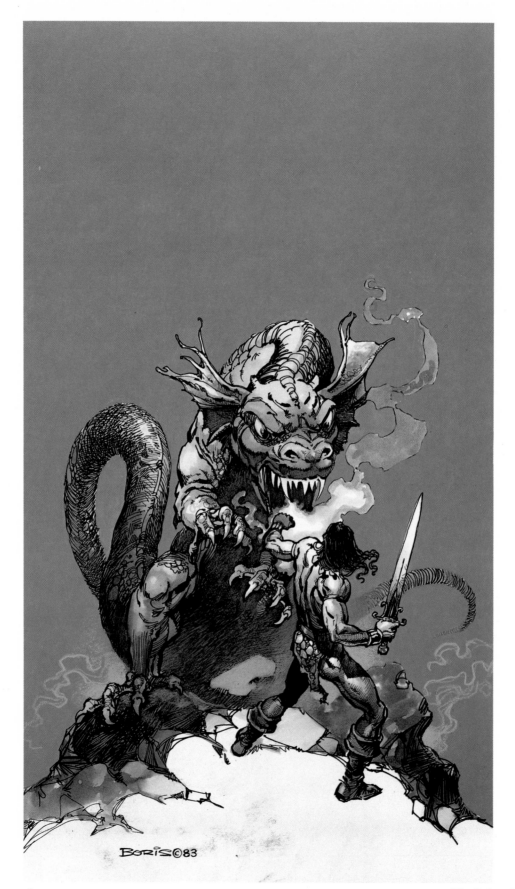

Coloured ink rough.

The Magnificent, Tor.

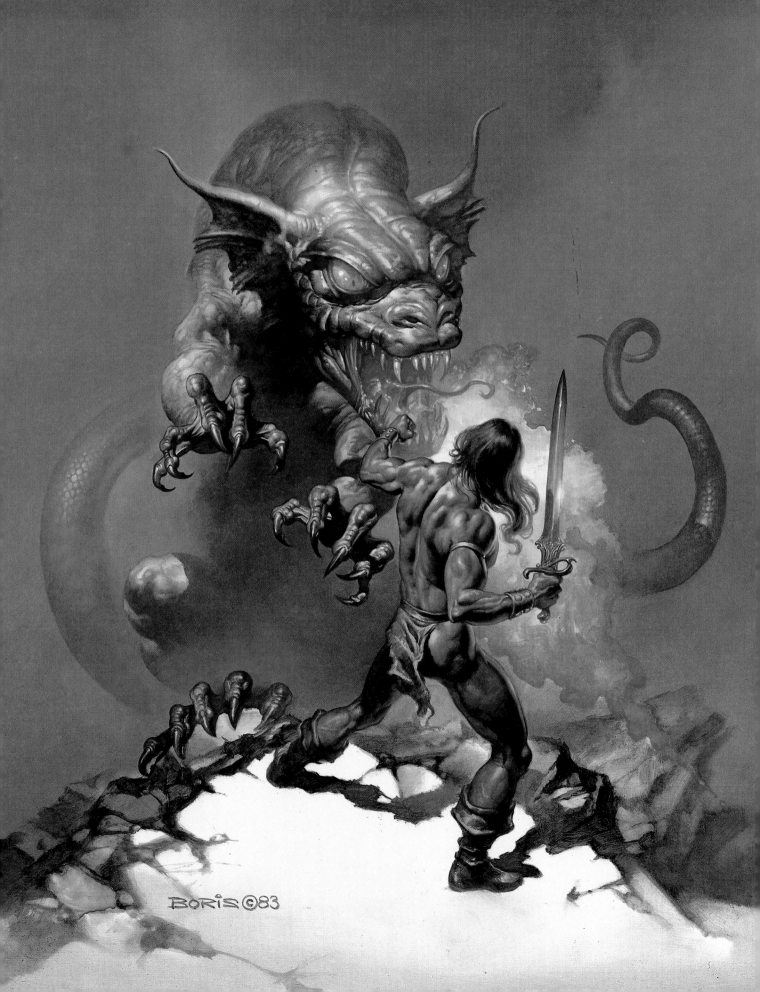

BORIS ©83

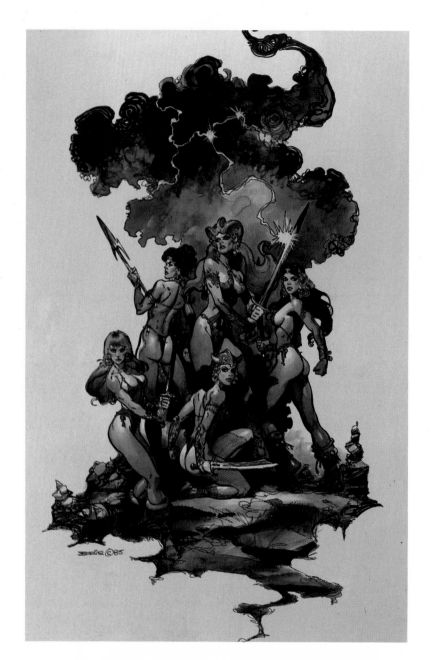

Coloured ink rough and pencil sketches.

Barbarian Queens, movie poster, New Horizons.

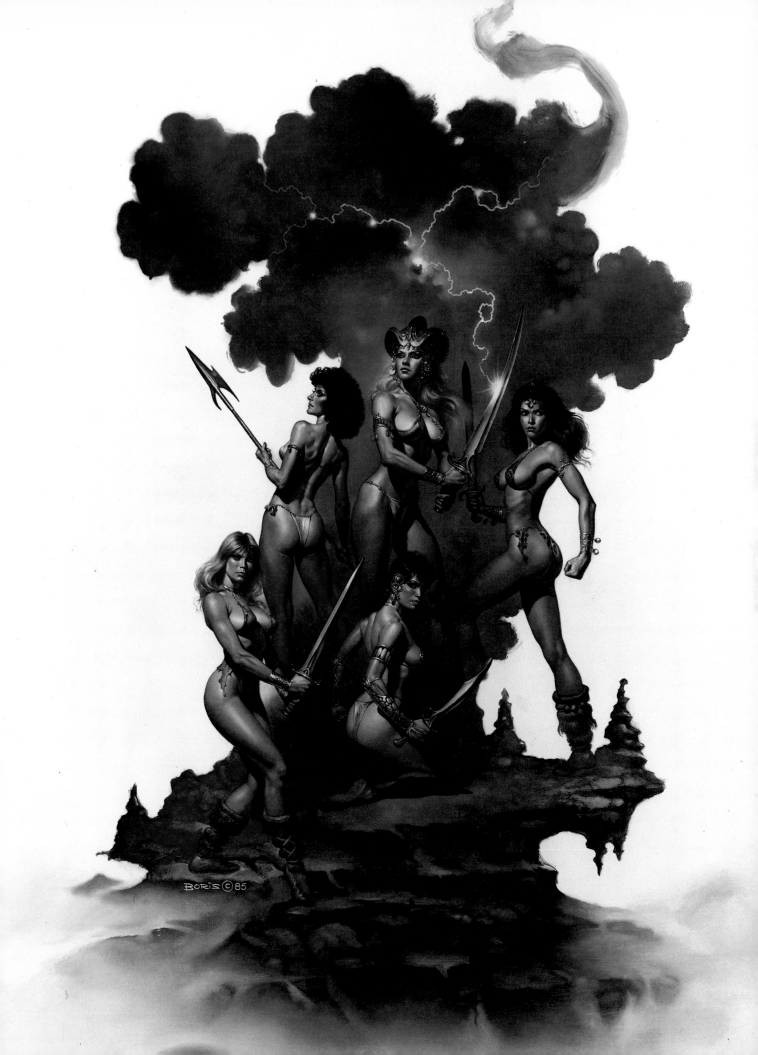

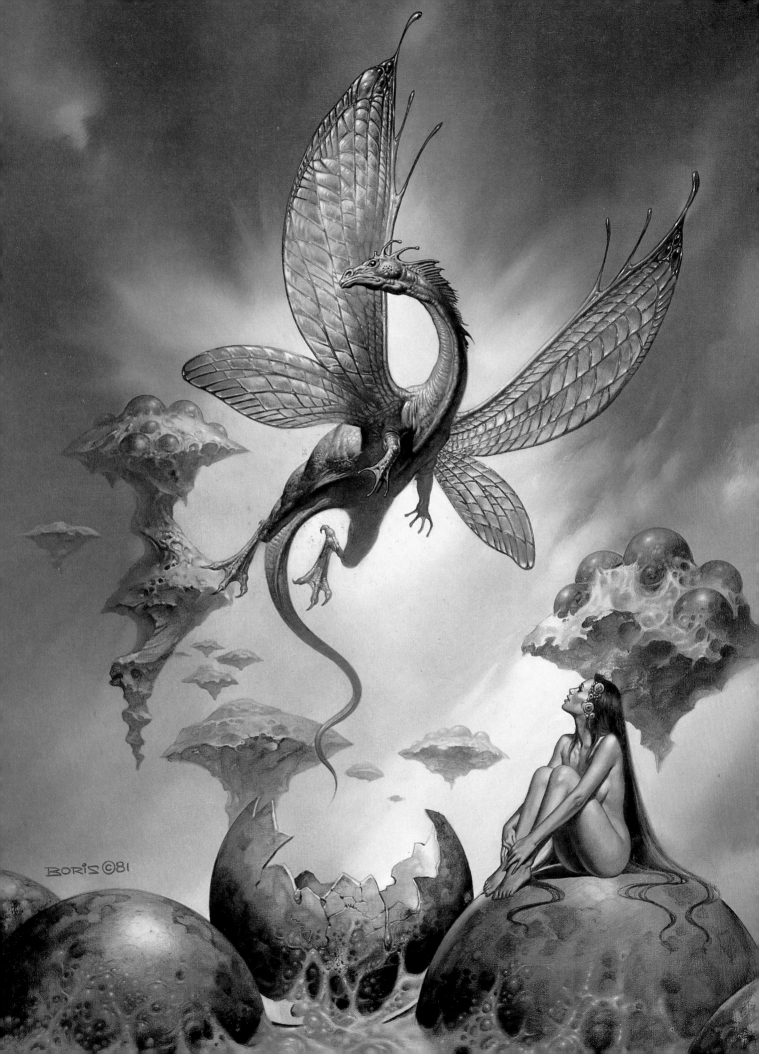

BORIS ©81

Painting & Underpainting

After I have completed my tracing, I transfer it to the prepared board. (I use Strathmore cold press illustration board with two coats of gesso.) I do this by retracing the entire sketch cleanly on the reverse side of the tracing paper. That way I don't have to use carbon paper, which might smudge or get the board dirty. I put the retraced side against the board and rub it down with a hard (6H) pencil. The original drawing on the tracing paper is done with an HB pencil, which is not so soft that it smudges readily but is soft enough to transfer easily.

Once the drawing is on the board (clean and accurate), I go over it with an acrylic wash. There is a question whether acrylic (which has a water base) and oil tend to separate eventually (according to the theory that oil and water don't mix). That depends on how you use the medium. I use the acrylic like watercolour — that is, extremely diluted. I prefer to use acrylic to oil (which also might perfectly well be used here) because it dries so much faster. Thus I can finish this stage of the painting in two or three hours and almost immediately be ready to put on the wash. This I do in oil. It is a thin, so-called "glaze" or transparent coat of colour — basically those colours that I intend to use in the painting. It must be transparent in order not to obscure the underlying acrylic sketch. These two stages constitute "the underpainting," which is, literally, what goes under the painting.

Some people use linseed oil to thin the paint and make it transparent. This is the more traditional method, but it takes quite a long time to dry. Linseed oil is in fact intended to make the paint flow more smoothly and retard drying. I choose to use paint thinner

Dragon's Birth, "Dragon" magazine.

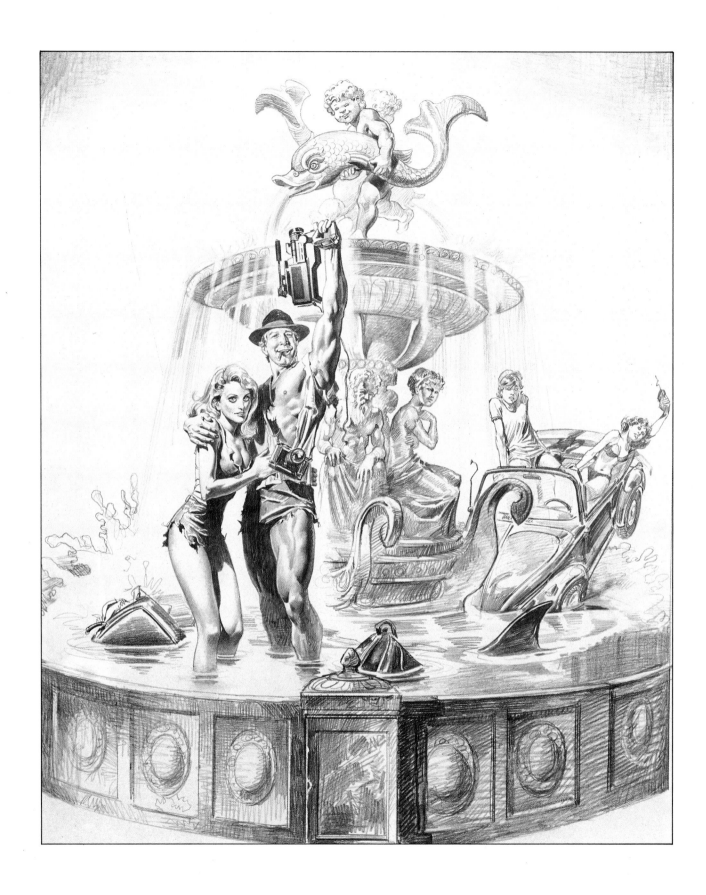

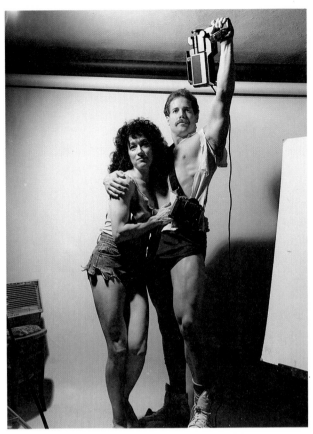

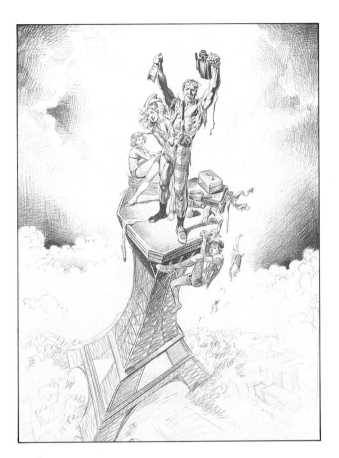

Polaroid of models for the pencil rough opposite.

Pencil drawing of second idea for the "Vacation" movie poster.

Early idea pencil sketch.

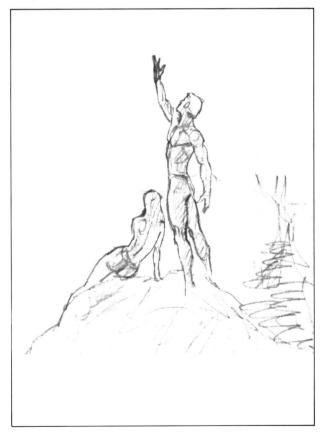

Pencil drawing for the movie "Vacation".

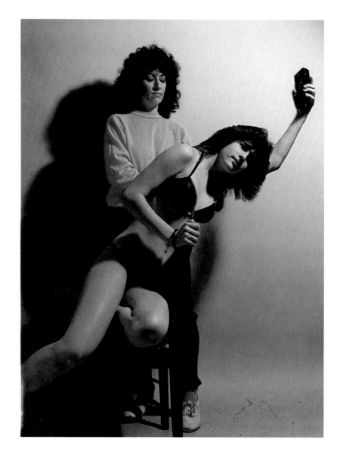

Polaroids of models for the final painting.

Pencil sketch of final idea.

Finished pencil rough.

82

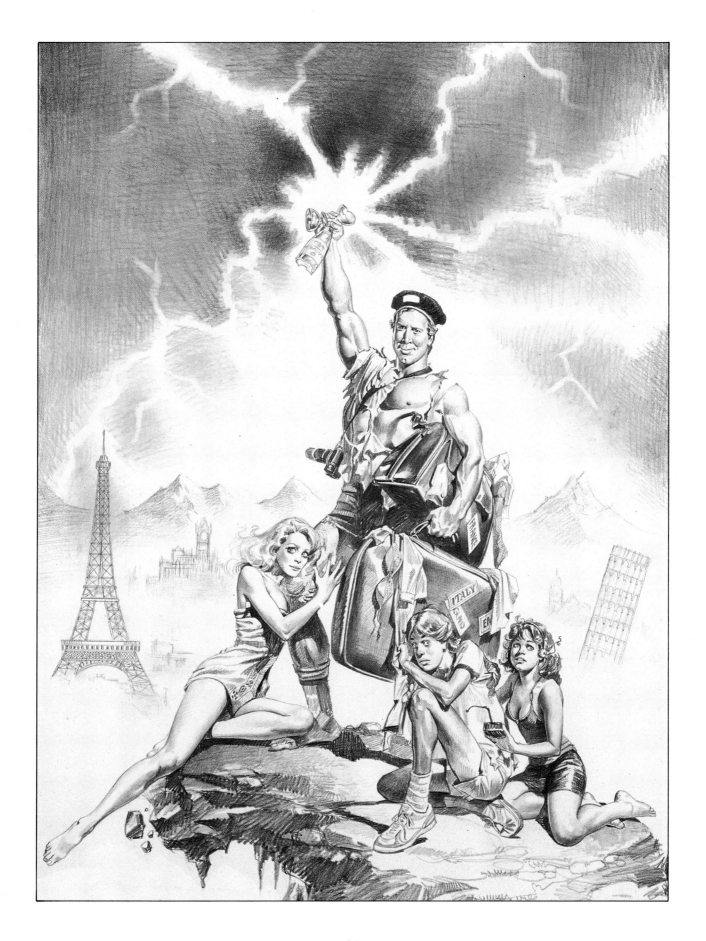

83

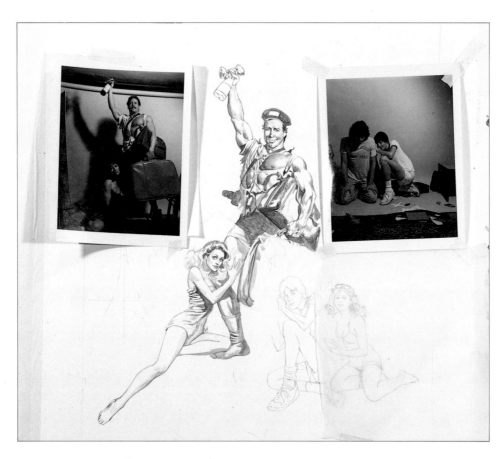

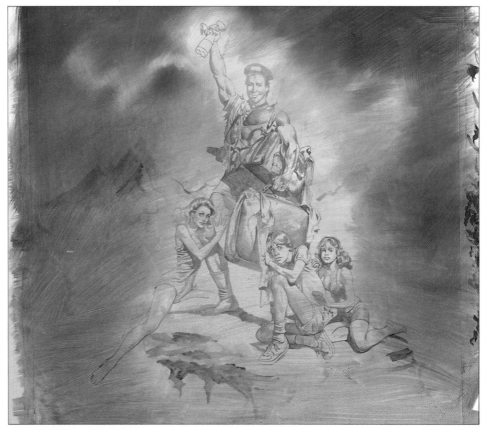

First and second stages of the painting.

Vacation, film poster, Warner Brothers.

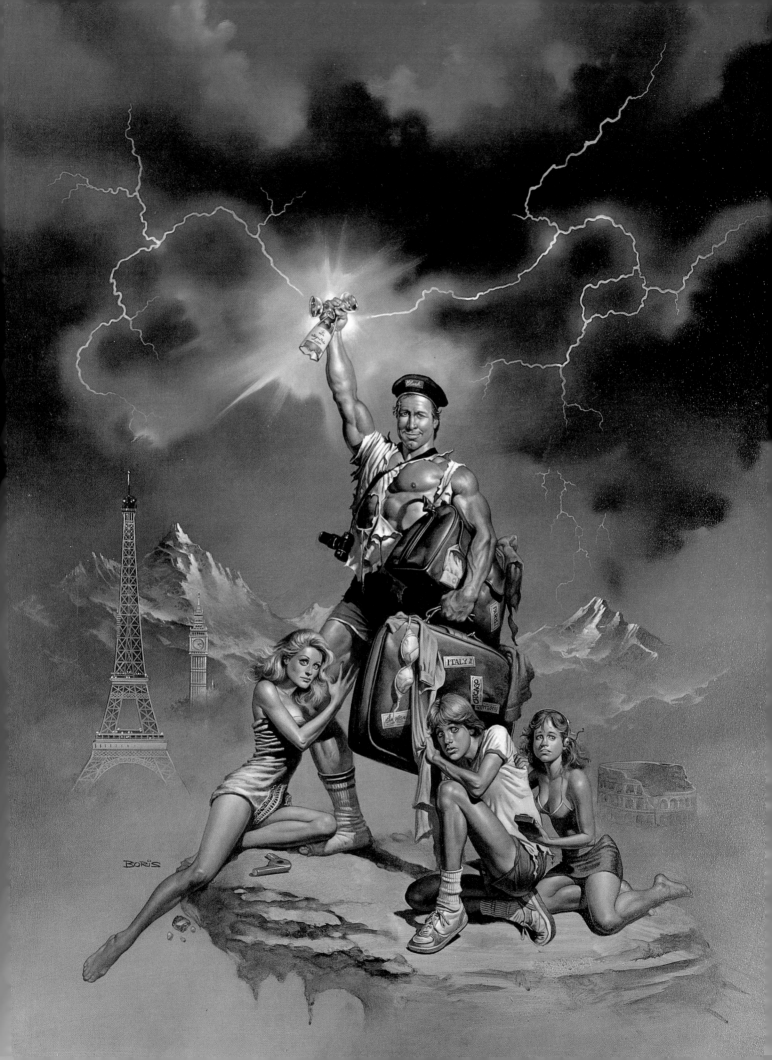

for the underpainting, not the turpentine produced for the artist but a paint thinner that is actually meant for house painting. It has two distinct advantages: it evaporates faster than turpentine and I can get the odourless kind, which is more pleasant to work with.

After the underpainting is set (that is, the sketch transferred to the board and the wash of basic colours that I plan to use applied), I start the final rendering. I always begin working on what is in the background first. I feel that the figures should be adjusted to the background in order to give them as much strength as they need. Also, when you are painting, things in the foreground should overlap what is in the background. This makes for clearer edges. I prefer using Winsor & Newton oil paints. As for the brushes, 75 percent of them are also Winsor & Newton.

I aim for a certain amount of subtlety in a painting, so I hardly ever use the colours just as they come from the tube. What makes some colours appear especially brilliant in a painting is the contrast with other colours that are somewhat muted. If you put a light

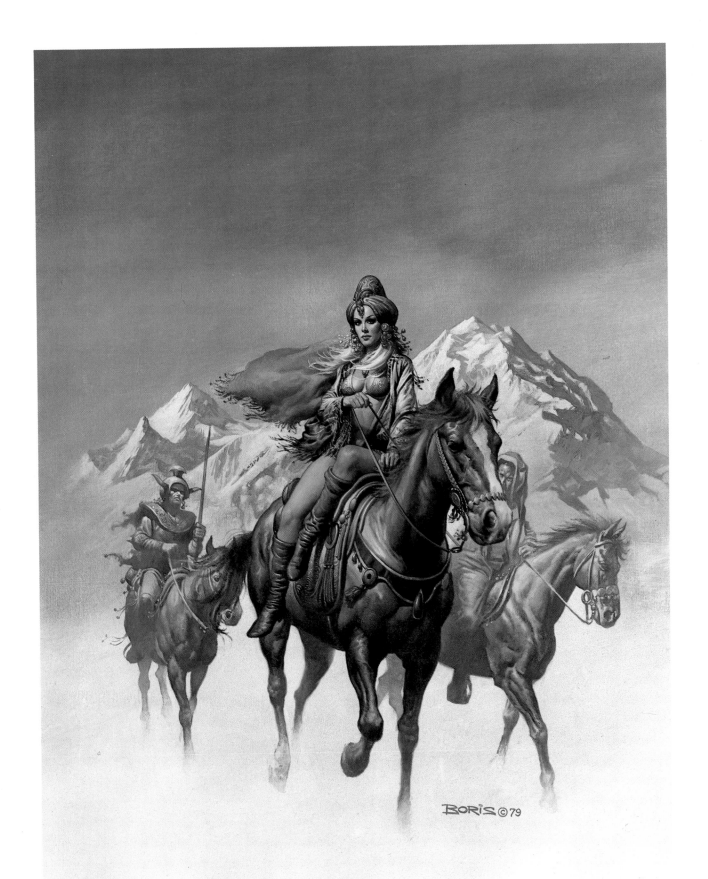

colour against another light colour, it stands to reason that neither will look at all high in contrast with the other. Since painting is creating illusions with colour, light, and shadow, the only way you can create the illusion of brilliance is by contrasting a bright colour with one that is less so.

To give colours a seemingly transparent glow it's necessary to keep them as pure as possible (i.e., not mix them with others) or actually make them transparent. If you have the white of the board showing through the colour, the light will bounce off the white to give a luminous, transparent effect. In order to use the paint this thin, I may mix it with linseed oil (which will also retard drying) or paint thinner.

One thing that is very important is to know when to stop working on a painting. This comes partly from experience. The more insecure you are, the more you tend to overwork a painting. Recently I went to a sketch class and saw the work of a woman who had a really beautiful quality in her quick watercolour sketches.

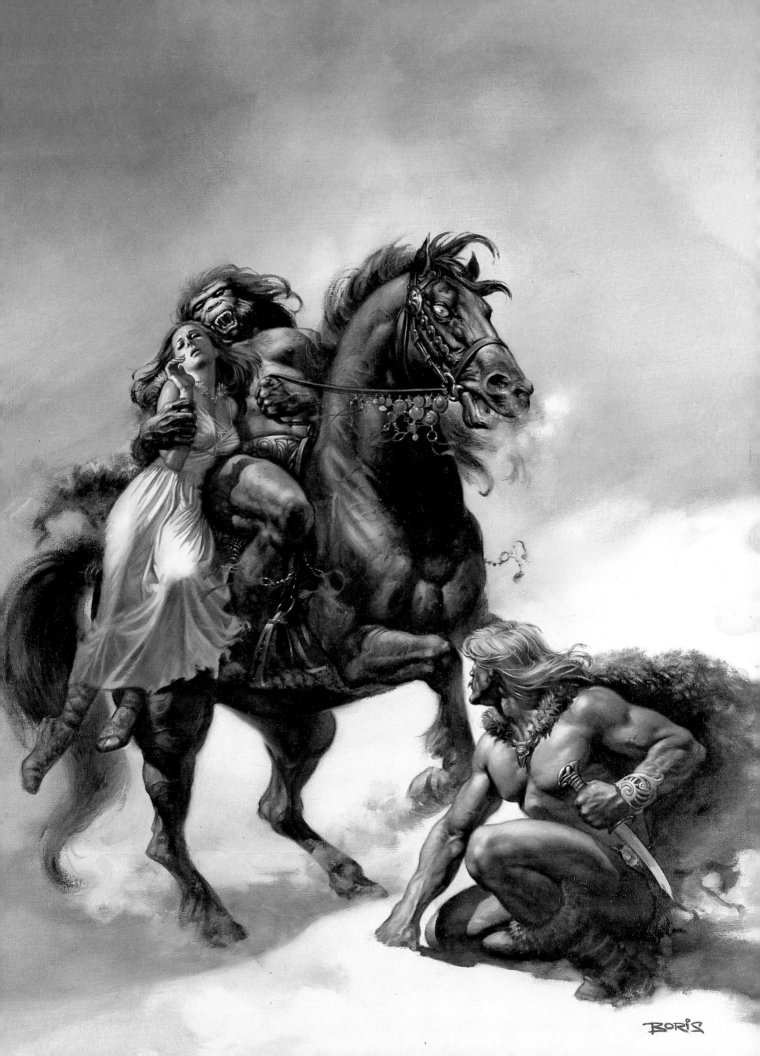

During the two-hour session, however, her painting became dirty and stiff. She worked longer than she should have. How much time you have for a given piece will certainly be a factor that influences how long you can spend on it. On the other hand, it sometimes happens that people stop before they are finished.

There is a tendency for people starting out with oil to get their colour so muddy that everything finally appears to be some shade of brownish grey. To blend colours successfully, you can't simply put one on top of the other. What I do is to put them *next to* each other and then blend the edges. In this way they remain clean and retain their own quality.

In order to have dramatic highlights (in the sense of vibrant or exciting colour) in a painting, obviously everything cannot be equally bright. Where to put touches of excitement may be a deliberate decision or it may happen by accident. But mostly such things are instinctive; one feels them. There is no formula. It should become clear from looking at a painting that it needs a touch of this here, a

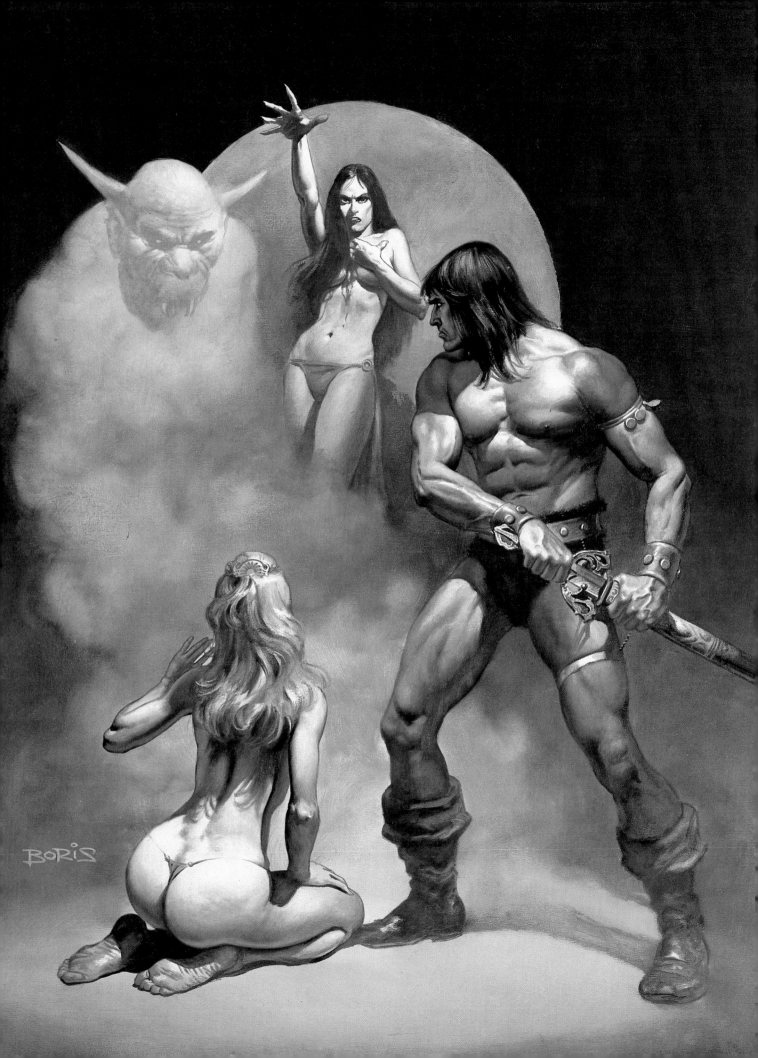

touch of that there. The more you paint, the more this instinct develops. If you must rely on a more intellectual approach, you might ask yourself: What are the main elements? What are the elements that should be emphasized?

In a typical fantasy composition of hero, lady and monster, you might ask: What do I want to make most important? The mountains in the background? The clouds in the sky? Perhaps, the sword in the hand of the hero? The hero himself? His face; the expression on his face? Or maybe, the lady? The monster? All of these are possibilities and the choice depends very much on what you are trying to achieve with the painting.

Occasionally I turn the whole canvas upside down. This may simply be for the convenience of being closer to a particular area that I am working on. Most often, though, I do it to avoid being influenced by familiar shapes or structures. It gives me a fresh look at the painting, a different look, and I am better able to concentrate on light and shadow and colour.

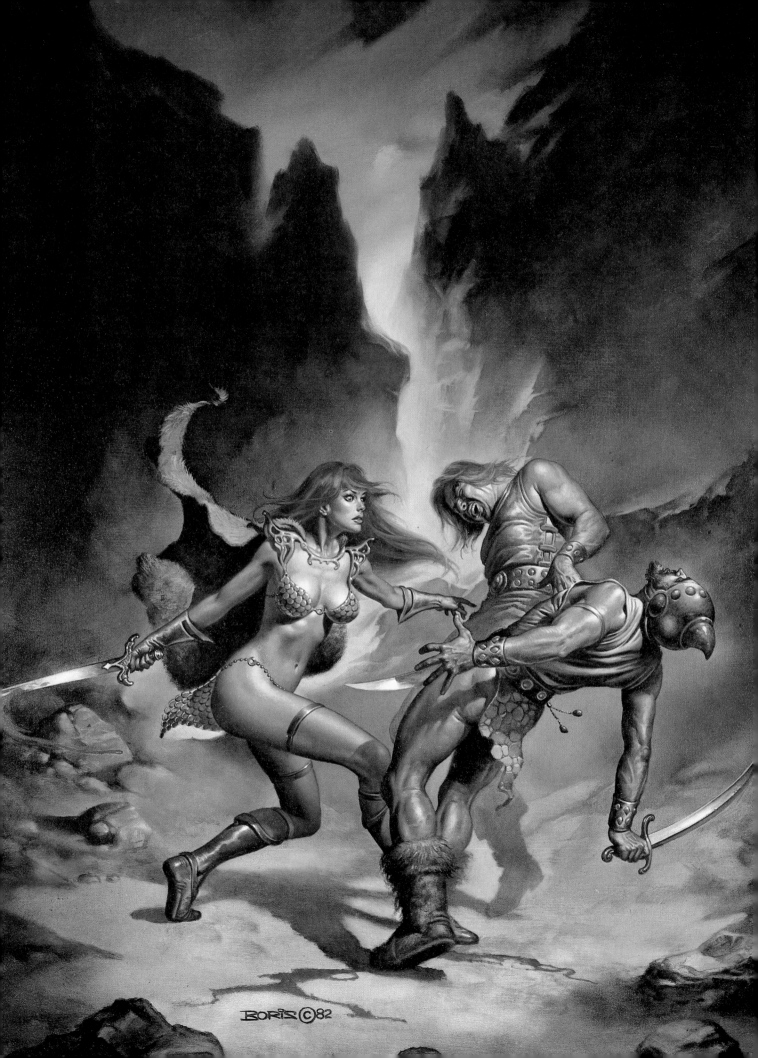

If you are painting an arm, for instance, the fact that you know what an arm is supposed to look like influences the way you handle it. But if you turn the whole thing upside down, you don't even begin to think that this is an arm, but rather that it is an abstract combination of light and shadows and colour.

When I finish a painting I give it one or two coats of retouch varnish to even out the colours. Paint thinner tends to make the colours look dull when they dry. In addition, depending on the amounts of linseed oil or paint thinner used, different areas of the painting are going to be duller or shinier. By varnishing, you even out the whole painting. Every colour appears with the degree of intensity that you originally gave it.

The classical painters put a heavy varnish on their finished paintings. This was with an eye toward preserving them, which is not one of my considerations. I'm mainly interested in having my painting look good for purposes of reproduction. Maybe I should be more interested in posterity, but I'm not at this time.

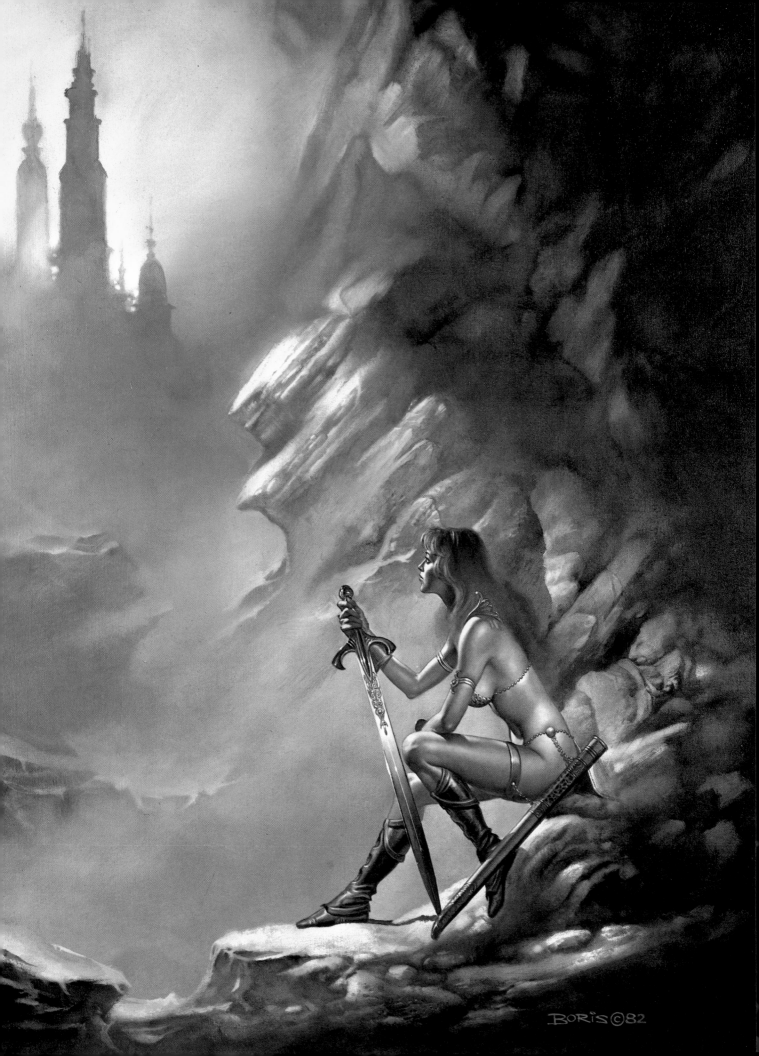

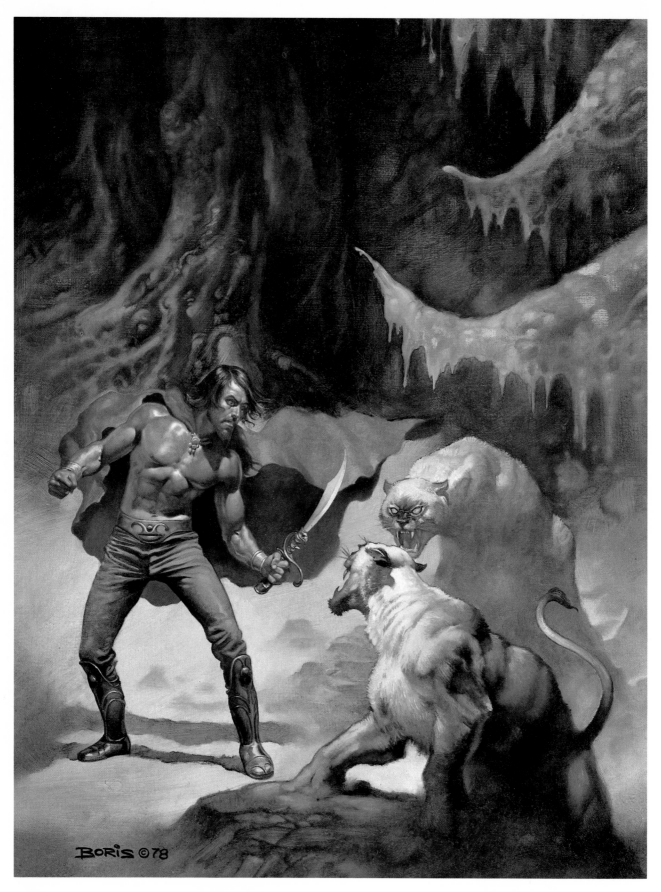

Wilderness, Doubleday.

Eternal Champion, Dell.

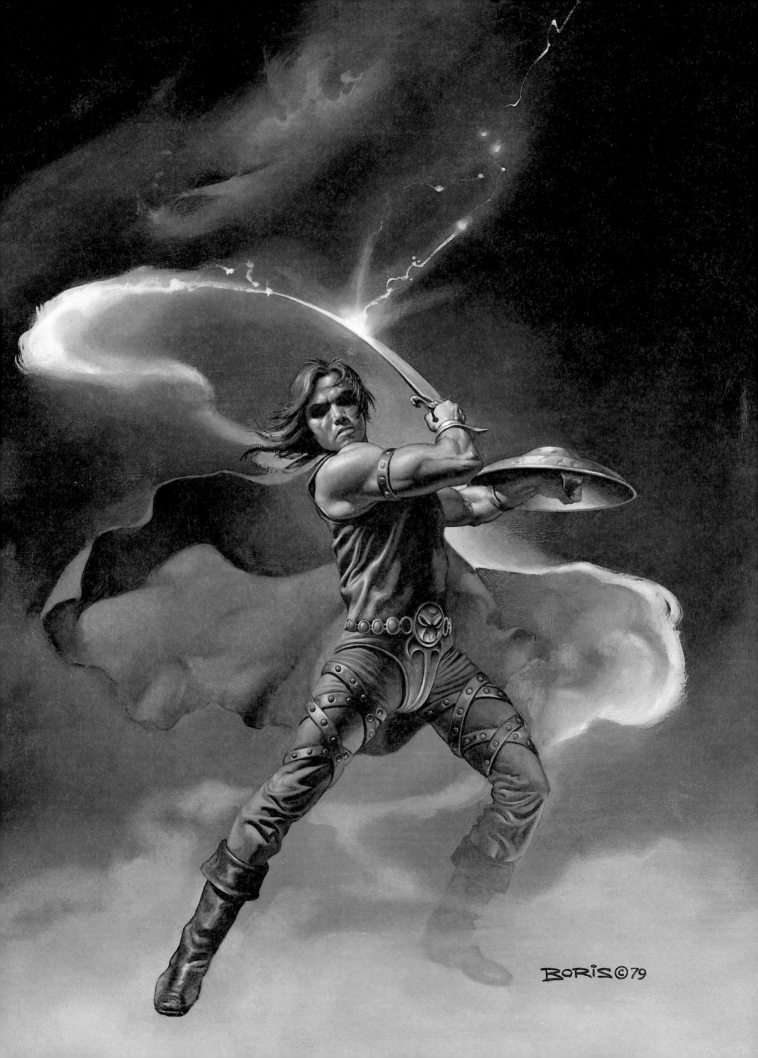

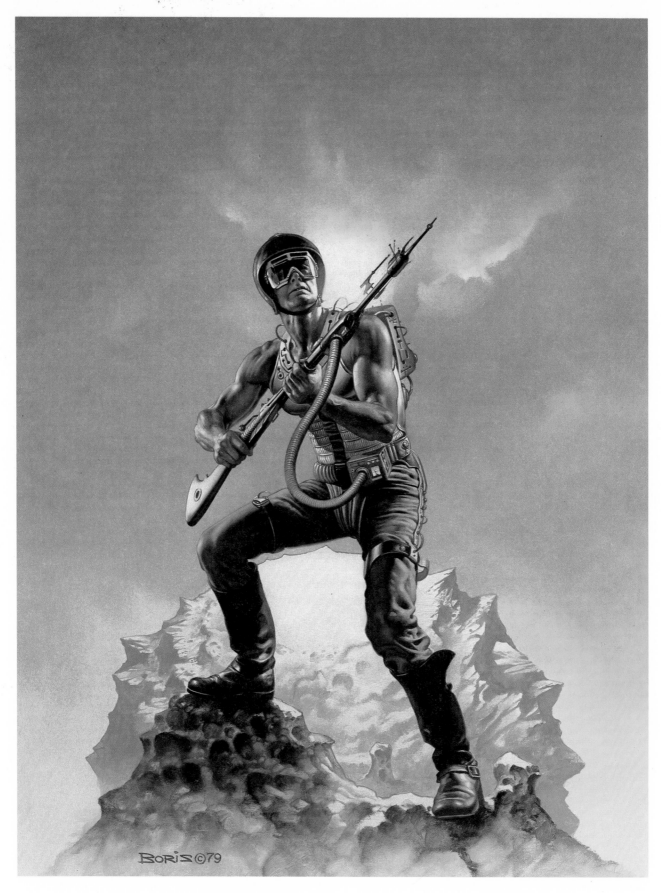

Mercenary, Pocket Books.

Adventurer, Ace.

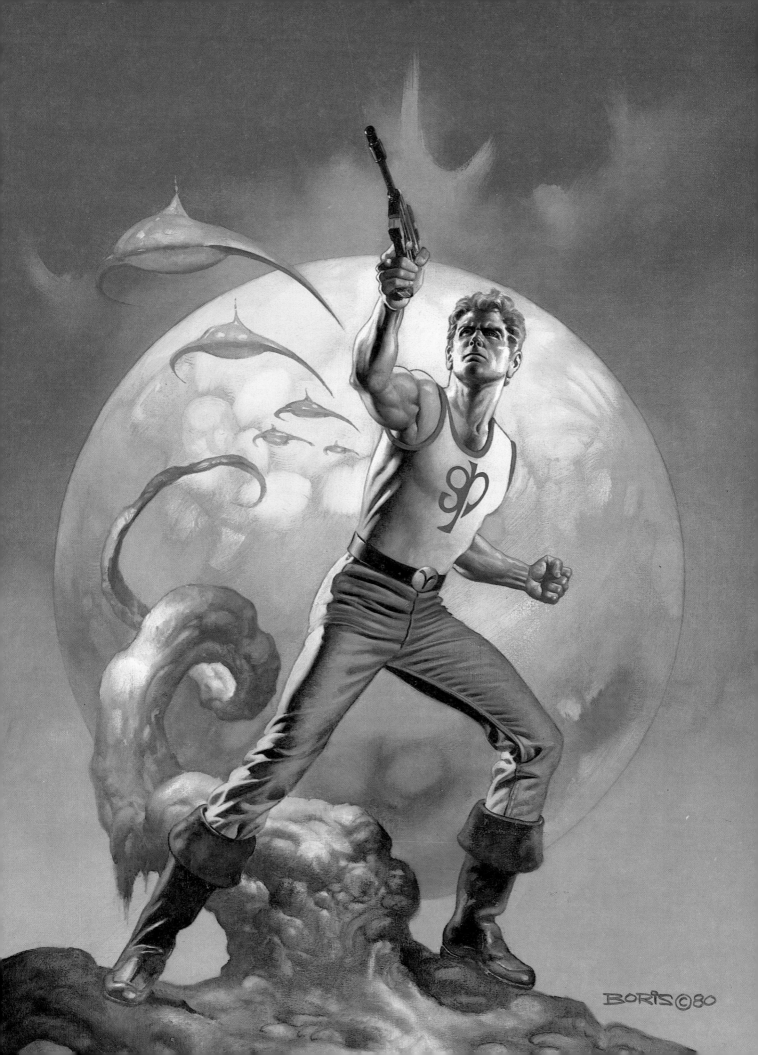

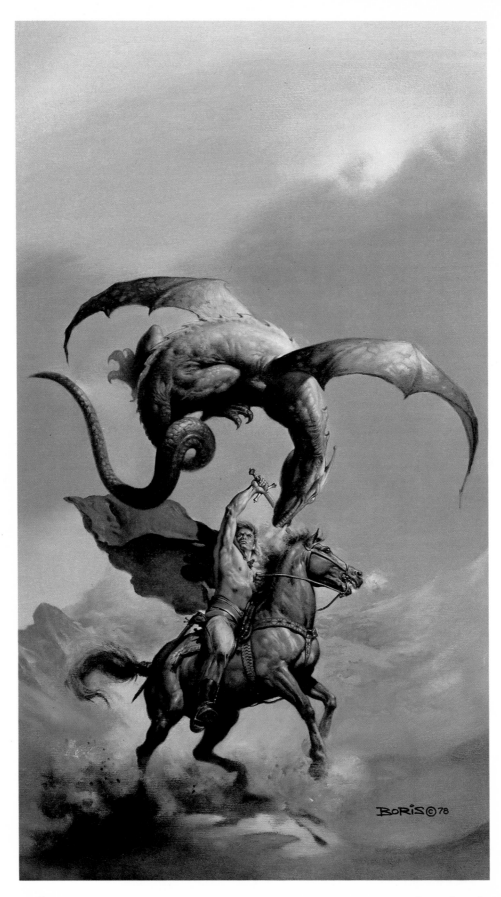

Flying Menace, Ballantine.

Space Guardian, Pocket Books.

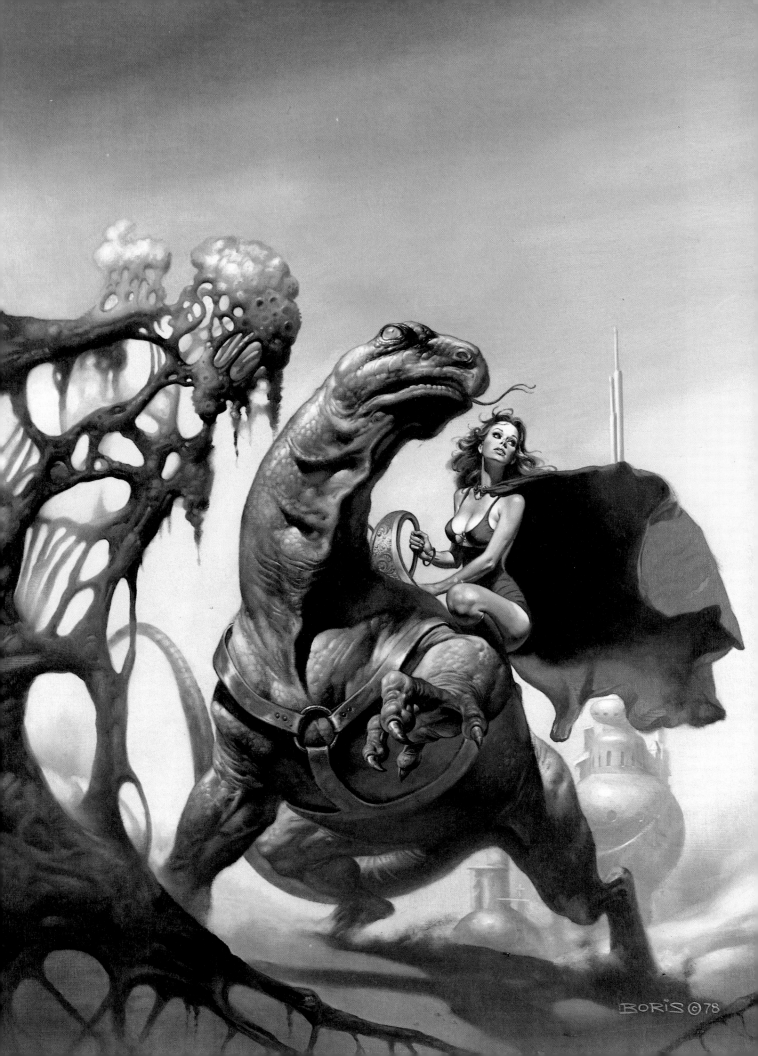

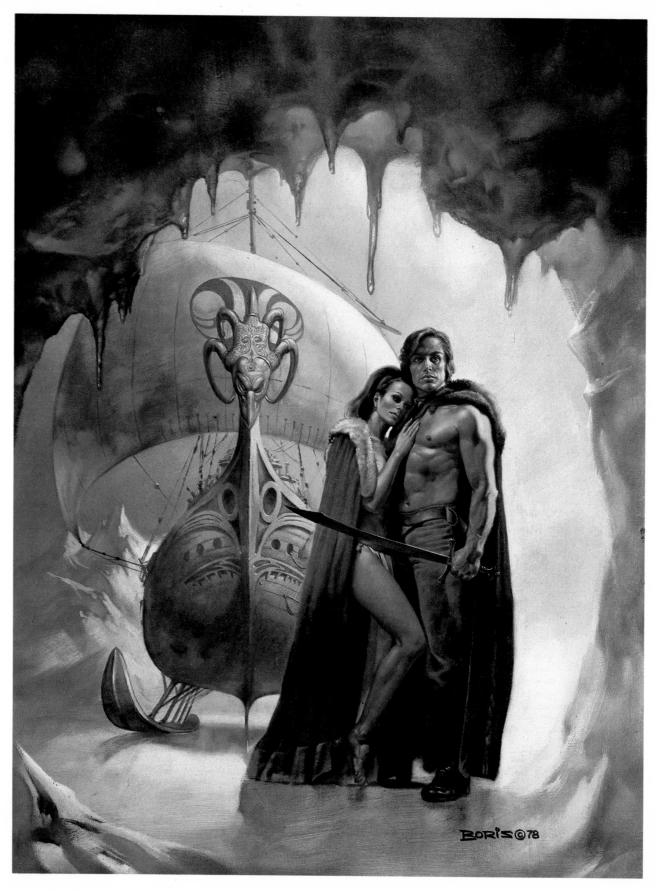

Ice Schooner, Dell.

The Witch and Her Familiar, Marval Comics.

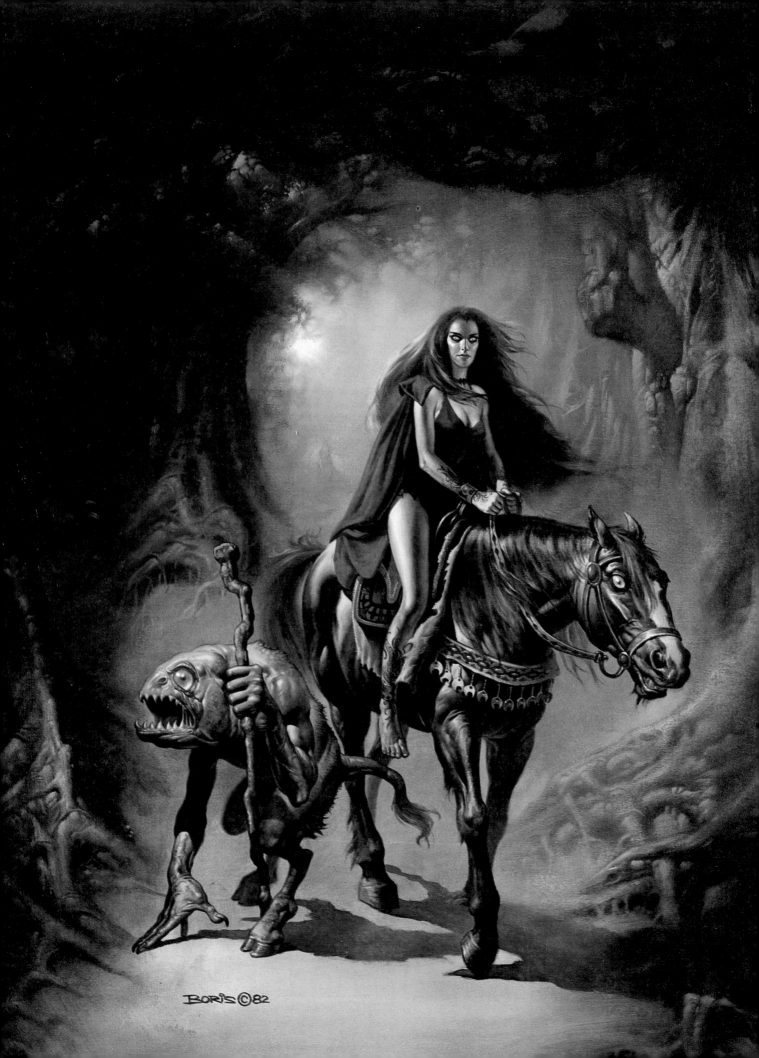

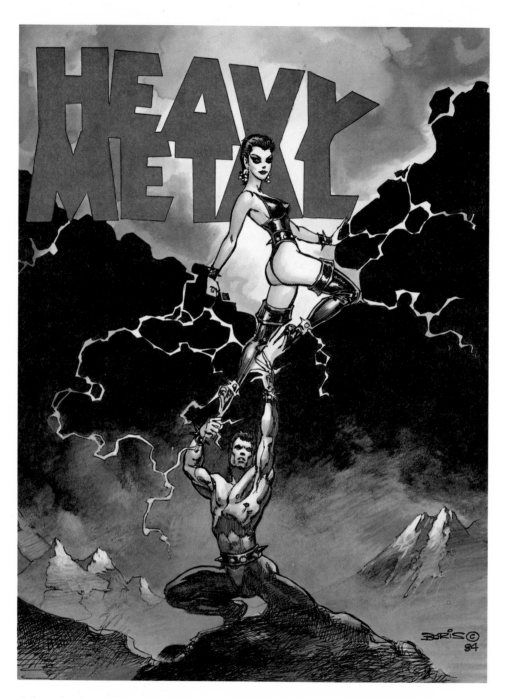

Coloured ink rough for Heavy Metal.

Painting for Heavy Metal

The first step, before beginning any painting, is the sketch. I prefer to use pen and ink. I usually use Rapidograph, even though it doesn't have as much flexibility as a crow-quill pen because I don't have to keep dipping it in ink. That convenience suits me much better and I can get a fairly interesting line with it. For colour, I use Luma or Dr. Martin's inks, which are transparent and very bright. In certain areas (the bottom of the sky and parts of the mountain) I used Prismacolour coloured pencils because they are opaque. For the same reason I also used a bit of white acrylic paint to highlight the mountains.

I like to do a fairly finished colour comp. How finished it is and whether or not I actually get to put colour on it depends on how much time I have. The more finished the sketch, the more I have been able to define and refine my ideas, as well as solve any problems relating to colour and/or composition.

The problem in this particular sketch was achieving a unity between the upper part where the lettering would be placed, which was very light and the lower part comprising the main portion of the painting, which was relatively dark. Since the concept was divided into light and dark, there was the danger of having the finished product look like two different paintings. The female figure became the unifying element. She broke up the blocks of light and dark. I designed the composition to have her appear in front of the title, thereby effecting a contrast between the dark outfit she wears and the light background, as well as between the paleness of her skin and the bright red of the lettering.

I gave the figure of the man a spotlight illumination in order to provide a good contrast with the darker background. A further unifying factor (evident in the final painting) is the reflection in the pale figure of the warm colours used in the upper part of the painting. The colours directly behind him are slightly warmed up as well, providing a faint echo of the figure.

In designing the cover of a magazine or book, space for the logo or title must be allowed for. How large an area is needed for this must be established and taken into consideration in the initial planning stages. That area should not become too busy or it will conflict with the title, which for publishers, is always of prime importance. As a rule, either a very dark or a very light background for the title area works best.

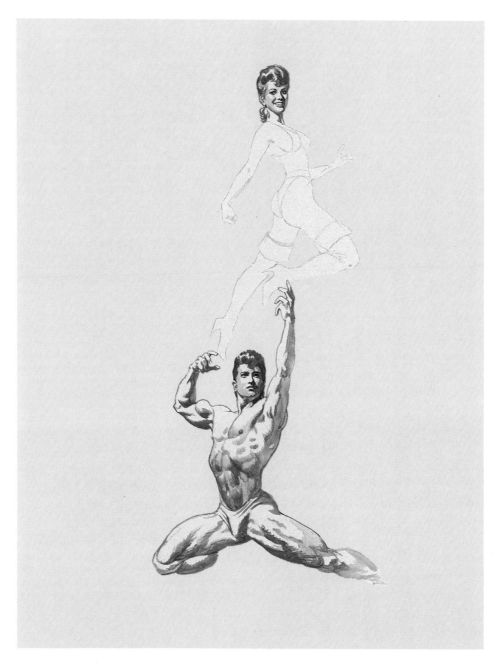

Underpainting for Heavy Metal.

Second Stage

~At the second stage I have already done my shooting and selected the photos I am going to use. When I conceived the idea for this painting I was particularly drawn to the two models I used because I felt they complemented each other so well. They had a punk look that appealed to me and suited the feeling I wanted in the painting. There are usually some slight variations between the sketch and the models' poses because the sketch is largely done without references and I like to give my models a certain amount of interpretive freedom.

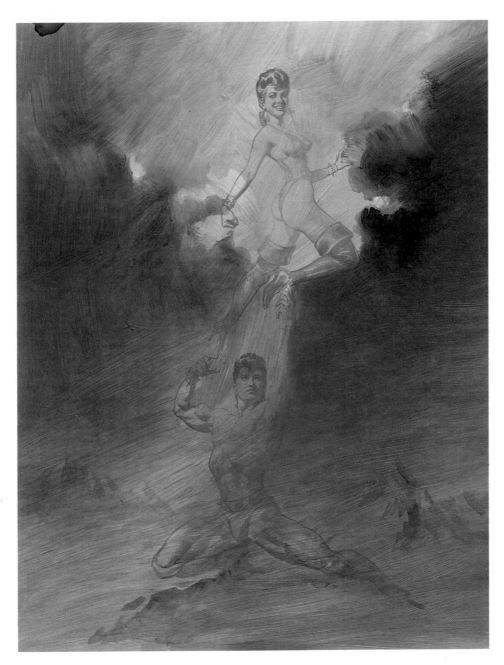

Heavy Metal, 3rd stage.

From the photos I did the tracings which were then placed on the board (according to the layout of the sketch) and finally transferred.

At this point I have done the acrylic wash (using burnt umber) on the male figure and the head of the female figure. You can still see the pencil lines under the wash. Even at this preliminary stage, I work out the rendering (the highlights, the halftones, the deep shadows) to a relatively finished degree. As I go on with the acrylic paint, I will add the shape of the mountains as well as the rock that the man is kneeling on.

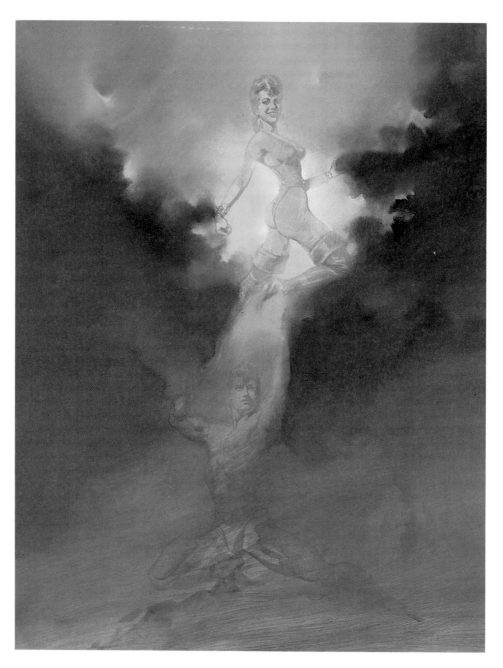

Heavy Metal, 4th stage.

Third Stage

The third stage was done with oil paint diluted (in this case) with one part cobalt dryer and three parts paint thinner. This mixture gave me a medium that dried in about five hours. If I had used the dryer by itself, it would have dried still faster. This way, however, I was able to apply the colour, which gave me a good foundation for the finished work, but which was still transparent enough for me to see the acrylic rendering underneath. Having done the colour sketch already, there is no guesswork or trial and error at this point. The thin glaze also gives me a more workable surface. If I were to start

painting directly on the gessoed board, the paint would not hold so well.

The paint or glaze is applied with a wide brush (number 18 or 20) since at this point I don't concern myself with the minor details. I'm not at all careful about keeping the colour within the lines. It's just a very rough and quick blocking and may take me half an hour or an hour at the most.

Fourth Stage

The background is the first thing that I render and I always work from the farthest elements to the closest. The farthest thing in this painting is the sky. I used fairly wide brushes for the large areas of colour and smaller ones (Winsor & Newton red sable no.1) for the detailing of the clouds and the rendering. The airbrush-like effect achieved in certain areas of the sky was done with a wide, soft dry brush.

Usually I mix the colours on the board rather than on the palette. I put one colour next to the other and blend them with a dry brush. Here I used a bit of white to tone down the lighter colours in certain areas in order to establish a contrast between the background and the figures. I find, also, that the background colour becomes more exciting if there is some variation from subtler toned-down colour to bright colour. Although there are light colours behind the upper part of the female figure, and darker ones behind the male figure, you can still see how much white is used directly behind these two figures.

Once the background is done, I can more readily determine what degree of intensity is desirable for the figures in the foreground. The main thing to take into consideration when doing the background is that it should be interesting but not so bright that it diminishes the impact of the main figures. The mountains in the background, for instance, should not be all that sharp. The tendency, when working on a particular area, is to make its elements as sharp as if they were the main focus of the painting; to think only of what you are working on at any given time as opposed to keeping the entire painting in mind.

Fifth Stage

I have kept the colours of the mountains in the background muted so that they will appear to be in the distance. Background colours should never conflict in intensity with what is in the foreground. This is not to say that they shouldn't be interesting. I have used purples and blues and in addition, have emphasized the peaks with lighter colours, while keeping the lower portions faded and misty. This also serves to bring what is in the foreground closer to the viewer.

Sixth Stage: The Figures and the Foreground

The skin tones here are generally warm. I used a great deal of cadmium orange, yellows for the highlights, and not much white. I avoided using siennas and ochres in the shadow areas because so many of these browns tend to give a dull feeling. Rather than use brown out of the tube, I make my own by using reds and greens. Sometimes, for the very dark shadows, I use mars black mixed with deep green.

I wanted the skin tones of the female figure to be light, and since she was placed in a light area I could use reflections on her skin. I was able to establish the contrast between her and the background area with the stronger, darker colours of her clothes, boots, hair, and wrist straps.

As for the male figure, I emphasized only his upper body. Too much contrast between his lower body and the background would draw attention away from the centre or main part of the painting. For the same reason, I lightened only that part of the ground on which he was kneeling and left the rest without much detail.

One of the things that I feel is particularly important in a painting is a sense of drama. This is created with effective composition and propitious use of colour and light.

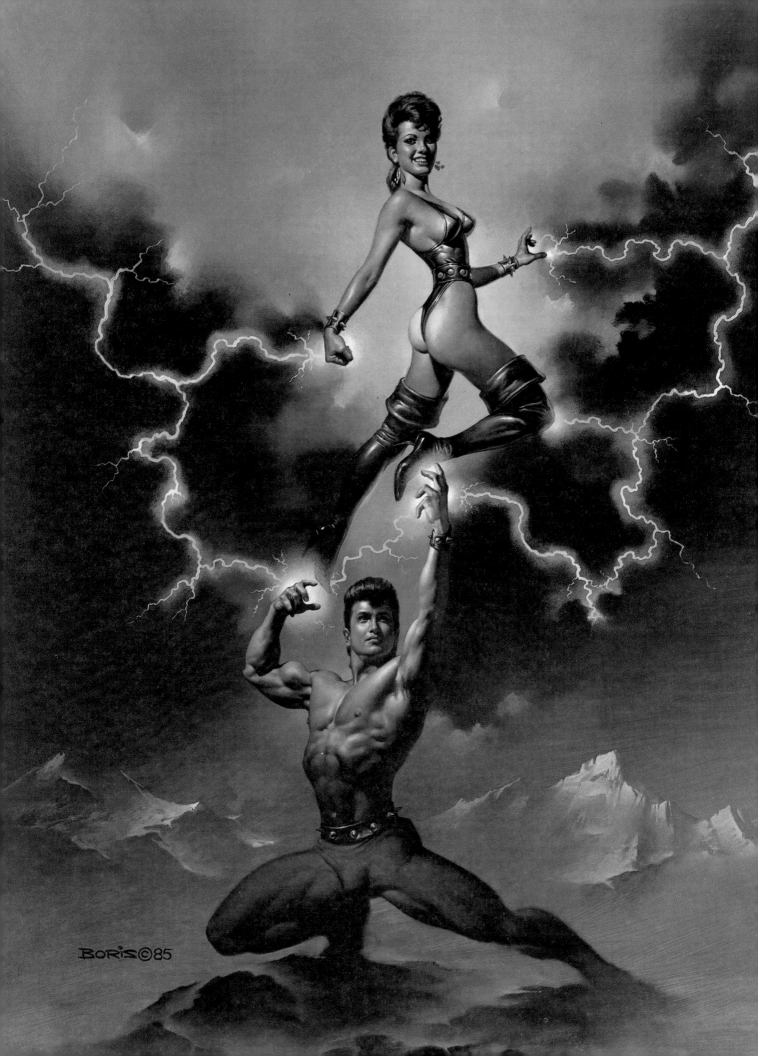

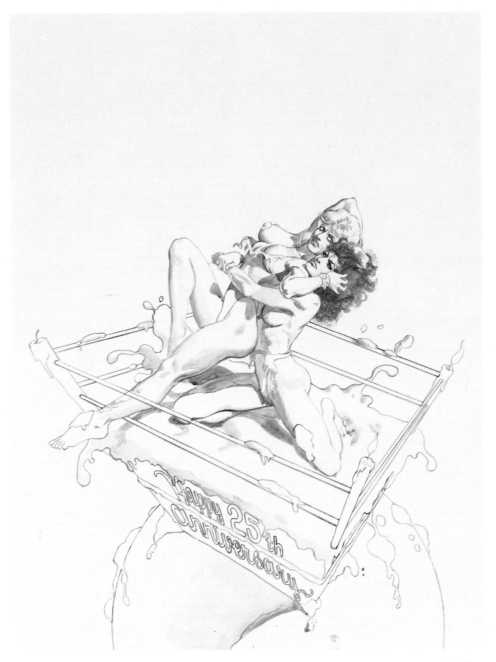

Female Wrestlers

The concept was given to me by the art director, so there was no preliminary sketch for this painting. I just made a thumbnail sketch for the shooting. Then I selected three photos and combined them to arrive at the tracing I finally put on the board. The first thing I established was the position of the two figures on the board: how they were going to be placed in relation to each other and to the negative space. Once this was clear, I designed the ring on the cake on which they were fighting.

112

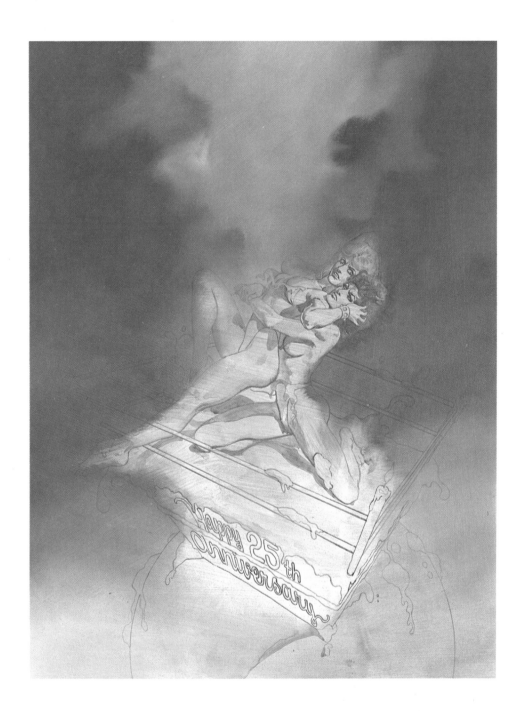

Second Stage

I worked the initial glazing and rendered the background more or
less together. As I was blocking and establishing the colours of the
background in my usual manner, things very naturally started to
happen in the sky. I wasn't too sure whether I wanted to go with a
light or a dark background. But since the title of the magazine for
which this was to be a cover had dark shadowing, which wouldn't
show up against a dark background, I opted for the lighter colour.
Also, since the painting was supposed to be a kind of spoof, it

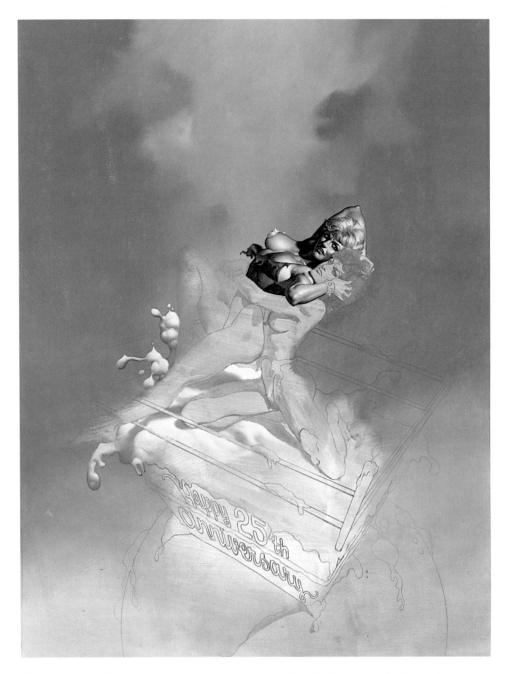

Rendering the figures *Female Wrestlers, the finished painting.*

seemed to me that the lighter colours would be more in keeping
with that feeling. As these things began to take shape, it occurred to
me that, rather than wait for the glaze to dry, I might as well
continue and use the thicker, more opaque paint to define the sky. I
went ahead and established the background, thus combining the
second and third stage. After that, it was just a matter of waiting
until it dried to start working on the figures.

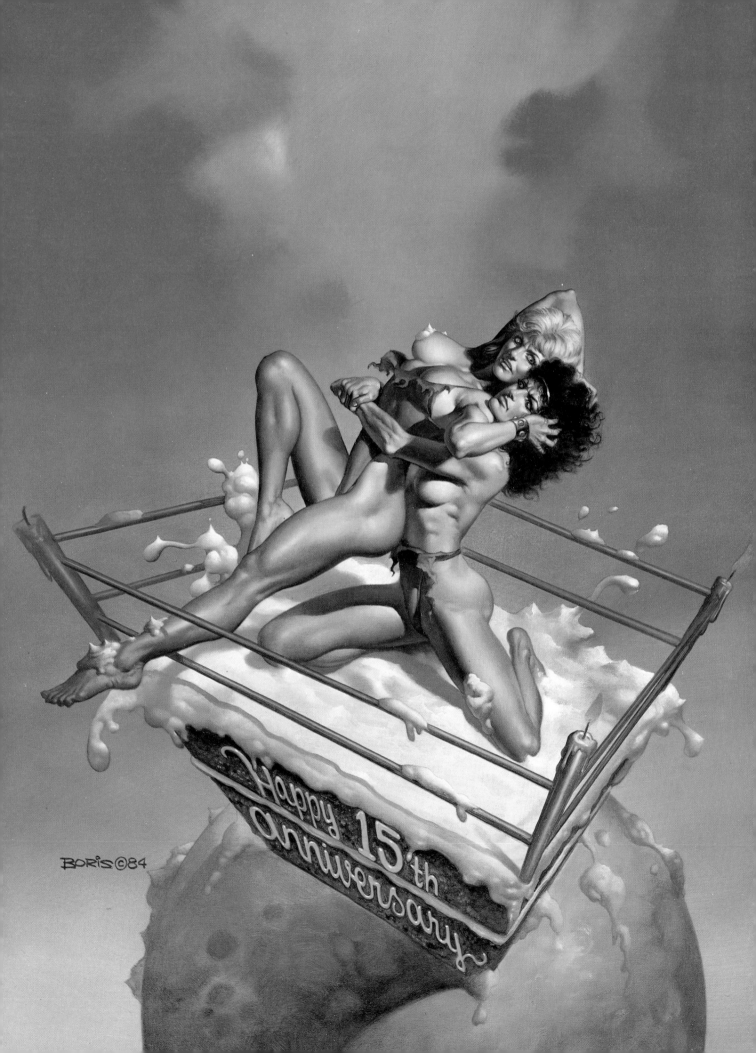

Rendering the figures

My way of working is to concentrate on small areas at a time. When rendering a figure, I begin by working first on the face and the head. From there I concentrate on the area of the neck to the waist and then the waist to the feet. Breaking the figure down into these sections allows me to stop at several points, should I need to, without worrying about the colours looking patchy or in any way different when I start again.

I wanted to keep the colours of the figures fairly warm, because the background was handled with cool colours — blues, purples, and so on. By making the figures warm I would create an interesting contrast. In order not to have the warm and cool colours clash, however, I warmed up the background area directly behind the figures by mixing some of the oranges with the blues.

The blonde girl is partly done here. I thought it would be interesting to contrast her platinum hair and red outfit against the tan colour of her skin. I also put strong reddish reflections in her shadow areas — under her left arm, for instance.

In the finished painting you can see the differences between the skin tones of the blonde and the brunette. In general terms, the skin tones of the blonde are a copperish tan with the breasts fairly light and the legs darker. In the brunette, although the breasts are also lighter, the rest of the skin has cooler tones. This is to establish a difference between the two bodies.

The whipped cream on the cake is handled with almost pure white in certain areas. (I normally reserve the absolutely pure white for the highlights.) This makes for a nice contrast with the darker skin tones.

I have had to greatly exaggerate the perspective of the cake. In fact, I had to distort it to make all of the elements work together. The perspective is not accurate, but it works in the painting; it gives a viewer the sense of how enormous it is, balanced there on the earth. To avoid the question "How could this work?" I kept the earth fairly unimportant, faint, and not that sharply defined.

116

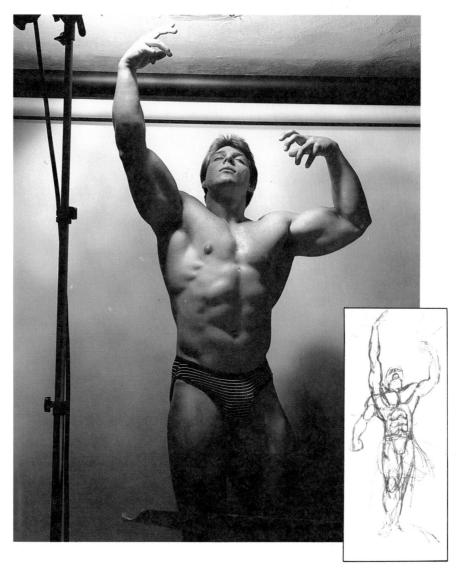

Chrome Robot

For this I also let the model do his own interpretation of the pose. Eventually I decided to flop the figure and reverse the position of the arms. It had, I thought, a more natural look, more of the feeling I wanted in the painting. Here you see the drawing done on tracing paper and taped to the board. I have done a certain amount of shadowing on the tracing and established the joints of the metal parts, as well as made slight additions to the figure itself: some kind of knob-like appurtenances where the ears would be, and at the hip joints and elbows. There is also an indication, though not particularly defined, of the sphere on which he is standing.

Since there was only a single figure in this painting, deciding on the most effective spot to put it did not present much of a problem. I did have to allow space for the book title when I transferred it to the board, though. The burnt umber acrylic rendering followed.

117

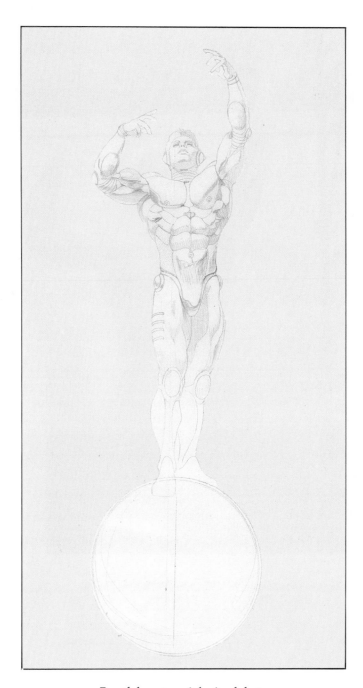

Pencil drawing of the final design.

Second Stage

In order to effect a strong contrast with the brightness of the metal, I made the background really dark, almost black. What I find most interesting in this particular painting is how I achieved the chrome effect — how I adjusted the human features, the flesh, to appear metallic. The reflections underneath the shadows are warm. The halftones at the height of the curves on the figure are cool. This I did not only to make it more interesting, or less visually monotonous, but to create a specific illusion. Chrome is generally

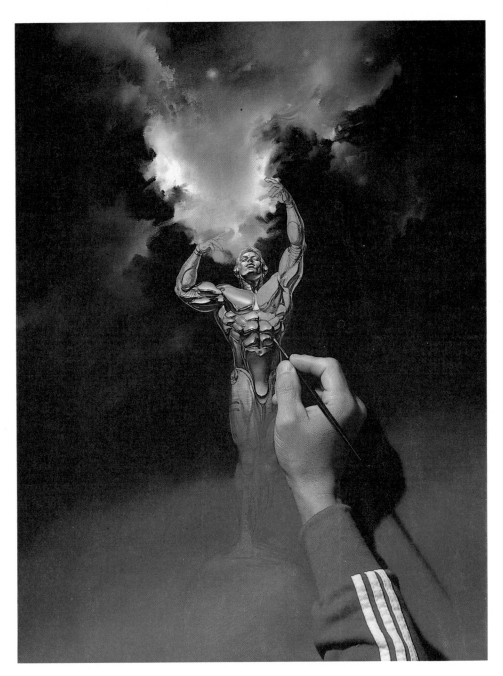

Development of the painting.

seen on a car. How is the light reflected there? The lower part usually reflects the road, the upper part the sky (the sky popularly thought of as blue and the road a warmer brownish-orange colour). Of course you don't say, on seeing my robot, "Ah, this reminds me of a car!" But the brain makes the connection between the remembered chrome and the painted illusion of it.

For the sphere he is standing on, I used the colours of the background.

Chrome Robot, finished painting, for an Isaac Asimov collection of stories.

The Finished Painting

I have kept the lower part of the body really dark and have done very little in the area of halftones or highlights in order to emphasize the upper part. Because the nebula is very bright, the reflections of it on the upper part of the body are quite strong.

I kept the sphere on which he is standing almost transparent. You can't tell whether it's glass or metallic. It simply looks much lighter and less solid than the figure itself, which remains the strongest element in the painting.

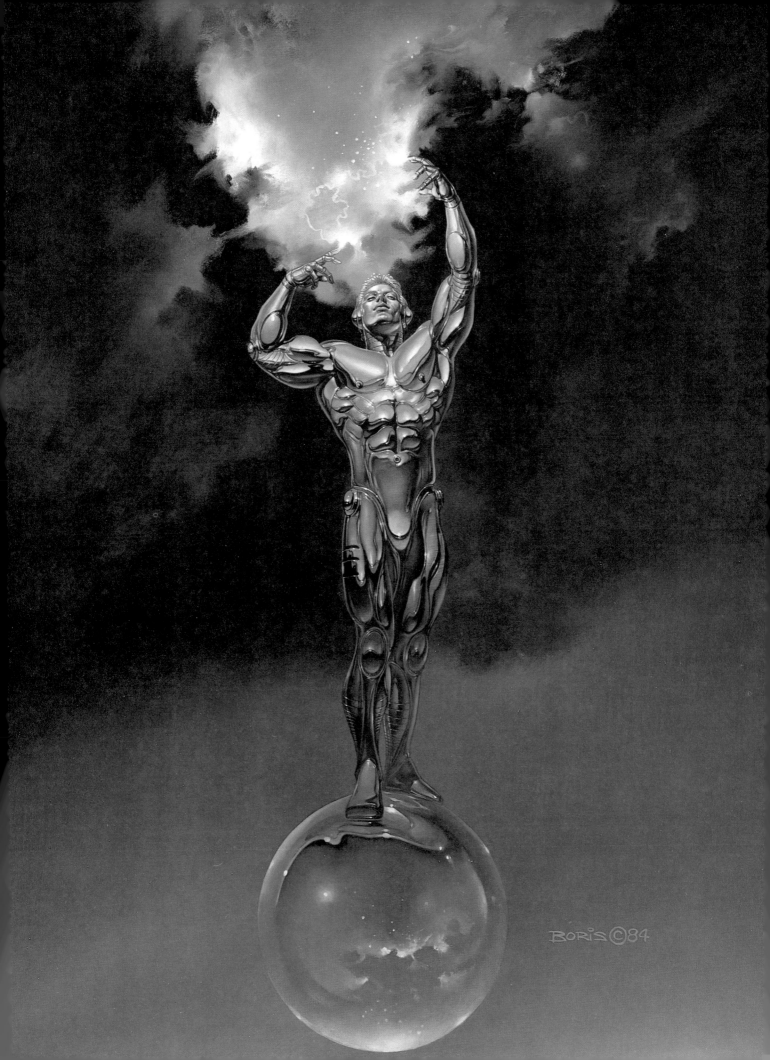

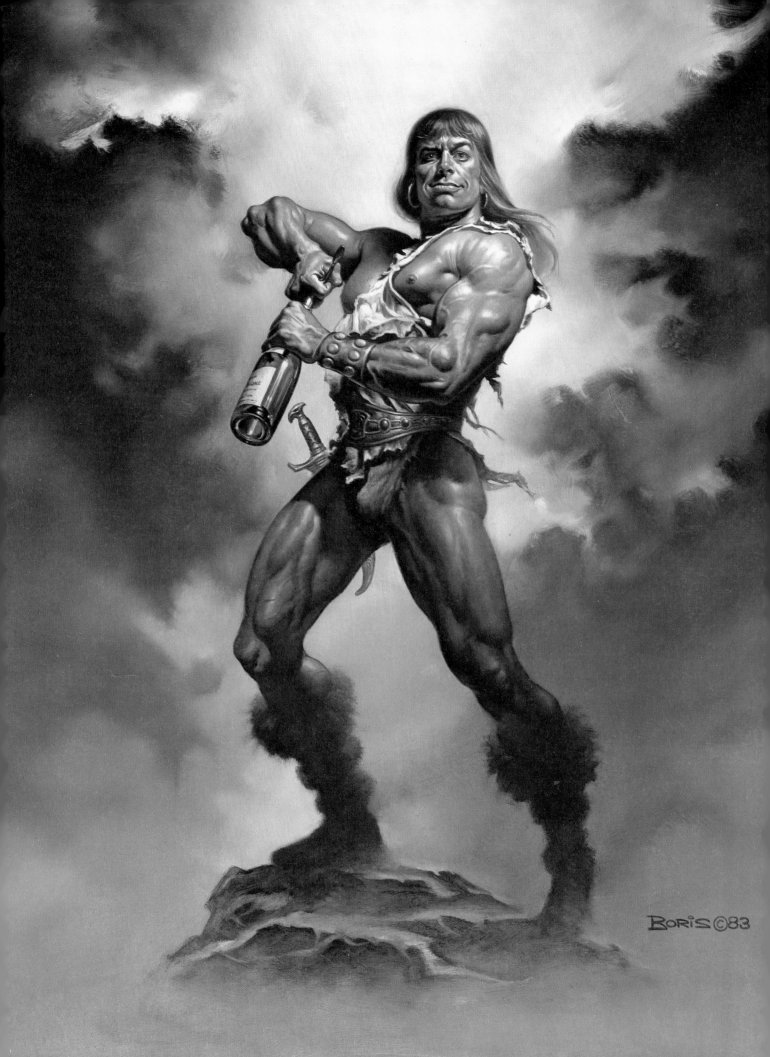

Preparing a Portfolio

A strong portfolio should be homogeneous; the pieces should be related in terms of subject and style. They should also be clean. As far as I am concerned, the pieces make a better impression if they are all about the same size. The saying, *"A chain is as strong as its weakest link"*, can definitely be applied here. It is better to have a portfolio of a few *good* pieces than to have one crammed with work, some of which is mediocre. A single lesser piece can detract from the impact of the whole.

I have had the experience of bringing my portfolio of mystery samples to an art director who commented, "This is all very nice. But, can you also paint nurses?" It is a situation that, preposterous as it sounds, is not unlikely to arise. For this reason it would be advantageous to have several different portfolios showing the various genres you can work in. In general, art directors categorize you. I noticed that one art director had me listed in his file index, not under V for *Vallejo* but under 'S' for *science fiction*. This despite the fact that I have done historical romances, mysteries, and gothics.

It is unlikely that art directors are going to see you on your first or second visit. The usual procedure is to call up and make an appointment to leave your portfolio with them. Often enough young artists have voiced the concern that their work will be

Conan painting for Playboy magazine.

Early paperback samples, in poster paint, unpublished.

pirated. This rarely happens, especially with established companies. If a firm wants to use the work, it would be to that firm's advantage to hire the artist rather than swipe the work.

It is a good idea to have a printed sample of your work that includes your name, address and telephone number to leave with art directors. Periodic follow-ups are also good. Every few months, as you have new pieces to show, you might make appointments to leave samples again.

When I first began taking my work around I prepared some samples in poster colours. At the time I made these samples, I used some printed paperback covers as guides, or examples, to emulate. I made the rounds rather unsuccessfully with these pieces. Art directors felt that although they showed a "certain amount of talent," they weren't that professional or saleable. I couldn't understand this. But the fact was that I was working in a shell. I did not compare my work with original work that was being sold, only with the printed book jackets. Obviously this did not give me an

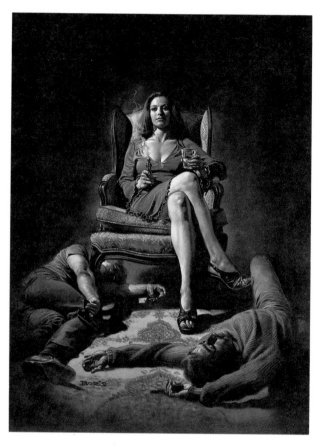

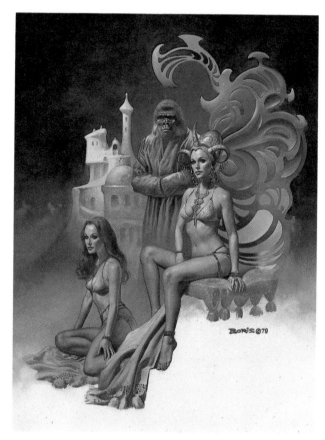

Hatchett, Ballantine.

Ape's land, Pocket Books.

accurate idea of how my work compared with that of other artists.

When I went to the annual show at the Society of Illustrators in New York for the first time, I had already sold some paintings for comic book covers. I thought my work was as good as anyone's, perhaps even better than most. Since the annual show is supposed to contain the best that has been done in illustration for the given year, I was eager to see how my opinion of my work stacked up against the facts. The show was truly an eye opener — it made me realize how far I still had to go. I was disturbed for about a week, but after that I was simply determined to improve. As such, the show was not just a humbling experience for me but an inspiration and an impetus toward growth.

Another benefit derived from studying contemporary work is an awareness of changing styles. Styles that were popular in the sixties and seventies, for instance, can appear quite dated now. Of course, one has to develop one's own style, one's own look. But it is necessary to be aware of what is selling today.

Afterword

Although fantasy illustration has been around for many years, more recently the field has taken a giant step forward. This is true not only in terms of technical improvement but also in its becoming more widely accepted. It is no secret that the spectacular fantasy and science fiction movies produced in the last decade have secured an enormous popular acceptance for it and, consequently, a more demanding and critical following. No longer appreciated by a mere handful, science fiction and fantasy illustration has been elevated to a finer art.

In books such as this, as well as in art schools, the amount of information that can be transmitted to the student is limited by what can be communicated in words or through demonstration. In the final analysis it is up to the individual artist to digest this information and put it to practical use in accordance with his or her personal goals. As such, nothing can substitute for time spent at the easel or the drawing board. Perseverance is often a greater asset than raw talent. What I have aimed to do is give some useful guidelines to ease the way.